The Meaning of the Cross

The Meaning of the Cross

Leslie D. Weatherhead

ABINGDON
Nashville

THE MEANING OF THE CROSS

A Festival Book

Copyright 1945 by Whitmore & Stone
Copyright renewal © 1972 by Leslie D. Weatherhead

Festival edition published February, 1982

ISBN 0-687-23970-2

Previously published by Abingdon Press in 1945
as *A Plain Man Looks at the Cross*

[32]Poetry on page 167 is reprinted by permission of Dodd, Mead & Company, Inc. from *The Collected Poems of G. K. Chesterton.* Copyright 1932 by Dodd, Mead & Company, Inc. Copyright renewed 1959 by Oliver Chesterton. Permission also granted by Miss D. E. Collins, holder of publishing rights in the United Kingdom.

PRINTED IN THE UNITED STATES OF AMERICA

This book was written (as will be obvious to the reader) before there was widespread awareness of the degree to which gender-specific language excludes half of the human race. Its message, however, is for men and women both.

Preface

WHEN a friend of mine learned of the title of this book, she said, "The trouble is that the plain man does *not* look at the Cross at all, and cannot be made to do so." I can think of several reasons for this:

1. He is not interested in religion. What is more, he thinks of it as an "interest" in the same category as music, gardening, or even golf. Some people take an interest in these things; others just don't. It doesn't appeal to them. That's that. There's nothing more to be said. He never thinks of religion as of vital importance—quite the most important thing in the world. To regard it merely as an interest which he can "take up" or not is more foolish than to regard his health as merely an interest and to be unconcerned if his loved one or he himself develops a killing disease. But we have not yet found a way of persuading the plain man that religion matters. A true perspective would show us that this is the most urgent task in our program if there is to be any "new world." For a new world needs new men, and new men have to be "born from above." There is no human way of producing them.

2. Many plain men who are interested in religion do not think it is relevant to national and international aims. A few who have experienced moral defeat, and who have lost all hope apart from faith in Christ, realize that the bankruptcy of all our reforms is that we have separated them from that

7

power of God which is made available through Christ. That realization is born of their own personal defeat which turned to victory only when they came back to him. But thousands of others, *interested* in religion, willing to give a watered-down brand of Christianity some recognition by occasional churchgoing, or even in the way they live their private lives, do not realize that, of the state as of the individual, it is sheer truth to say, "Except the Lord build the house, they labor in vain that build it." So the house is wired for electric light and power, and all the gadgets of modern scientific inventiveness and resourcefulness are duly fitted—and very impressive they are—but the house is not linked up with the mains, and is dark and cold. What a world this would be if all the wit of man's devising had, running through its inventiveness, the power and purpose, the supernatural energy of God! As it is, having made our schemes and outlined our plans, we fail because we haven't enough spiritual power to carry out our own planning. We can devise the apparatus, but we are not linked up with the main source of supply. We don't *really* believe in any power except our own. The supernatural is not in vogue. It is old-fashioned to talk of it. We forget that on every new level of achievement man remains too selfish to meet the spiritual cost of his own plans. A new world demands more unselfish service than he has power to meet of himself. He falls away unable to meet the spiritual requirement. He is like a man who plans gloriously and writes out checks to meet the cost of his plans without having enough in the bank to get the checks honored. The world would be paradise already if planning and scheming and scientific resourcefulness were all that is needed. What we need is

such a spiritual revolution that converted men will, even at cost to themselves, direct man's discoveries only to spiritual ends.

3. Even those who go further turn away from the Cross. Christ as the Teacher of splendid but rather impractical ideals? Yes! Christ the Hero? Yes! Christ the Communist? Yes! Christ the Martyr in a good cause? Christ the Example? Christ the Revealer of the nature of God? . . . The plain man says Yes to all that. But when one uses the word "Saviour," one feels that the plain man reacts as a trader might react if in Britain one offered him francs, or if in France one offered him rupees. The word "Saviour" is not current coin in the verbal country in which his mind lives. He feels at once in a strange country. And this is true of most of our theological terms—atonement, salvation, justification, redemption—one could cite a score.

The average plain man rarely thinks of himself as a sinner needing salvation. He will tell you that he's a pretty decent chap. He is, too. He isn't conscious of many "sins." When he is, he often nobly endeavors to do better. If you used the word "saved," he would ask you, "Saved from what?" And if you said, "Hell," he would think you old-fashioned, frightened by a bogey belonging only to superstitious minds. He doesn't believe in hell. All that, he feels, is gone.

This being so, he doesn't get further with the Cross than believing that a brave man died for a cause he believed in. The Resurrection he strongly doubts, save that, here and there, a belief is held in the spiritual survival of all men, including Christ. If you speak of "communion with a risen Christ," of "union with Christ"—which was the very heart

9

of the message preached by the earliest apostles and missionaries of Christianity—then you are out of his mental country at once, and in a land of theological terms which he doesn't understand and which he secretly thinks of as having no meaning at all, save to parsons and theological discussion groups.

The truth is, we have "missed the bus" with the plain man. Miss Dorothy Sayers says that the story of the Cross is "The Greatest Drama Ever Staged," and she rightly accuses the church of making it tame and uninteresting, unconvincing and irrelevant. She herself has succeeded magnificently in making the plain man *feel*, both in radio plays and in her published book, *The Man Born to Be King*.

Somehow we've got to make the plain man *think* again. I have great sympathy with him. I can understand why he has been put off religion and why his mind has been affronted by theories of the Atonement and why he has been reduced to the do-as-you-are-done-by religion which most decent men follow, but which is no religion at all.

Yet I believe:

1. The Christian religion is the fullest revelation of the nature of God that exists. Christ is the clue to God and the solution of man's hardest problem.

2. To be right with God is the most important thing in the world.

3. To be "in Christ"—that is, in vital communion with him—is the only way of being right with God and the only mode of existence that deserves the word "life" at all. In Paul's grand phrase, "Life means Christ to me." [1]

4. We are all guilty sinners torn in a conflict between

[1] Phil. 1:21 (Moffatt). See also Gal. 2:20.

what we ought to be and what we have power to be, and there is no way of solving that conflict except through the saving power of Christ.

5. Unless we tap that power and live that life, no reforms or schemes for a new age will come to anything, and our own lives will sink back into futility and compromise. Middle age and old age will find us disillusioned, dull, dissatisfied, gradually giving up the quest for completeness and fullness of life. We shall have missed the beauty and sparkle and meaningfulness of life, the deep satisfaction in living. We may possess many things and achieve fame, but we shall miss joy and peace, and probably fear death. "I came," said Christ, "that they may have life"—abundantly and forever.

6. The Cross of Christ is the clue both to understanding and to releasing into our lives that saving power, and the Cross is "of a piece" with a ministry of Christ begun "before all worlds," continued in his life on earth, consummated in his death and resurrection, and carried on still to the immeasurable benefit and only hope of mankind.

My own life is such a poor affair that it may seem to give the lie to my beliefs. Yet I hold them; and because, for me, in the last thirty years a growing light has gathered about the Cross, so that now I can faintly glimpse part of its meaning and significance, and because it is the pledge of that love which is my only salvation from despair—which is another word for hell—I publish these chapters in the hope that readers who have little time for study, but who care and who seek, and who are prepared, not merely to read superficially, but to study these chapters and consult their New Testament as some of its great texts are quoted, may

find some light for their minds, but, more importantly, some ground for their faith, and, most importantly of all, an incentive to surrender again and again to that awesome love of him

who for us men and for our salvation came down from heaven, and was incarnate by the Holy Ghost of the Virgin Mary, and was made man, and was crucified also for us under Pontius Pilate; he suffered and was buried, and the third day he rose again according to the Scriptures, and ascended into heaven, and sitteth on the right hand of the Father; and he shall come again with glory, to judge both the quick and the dead, whose kingdom shall have no end.

A Questionary has been added in the hope that it may be of service to discussion groups. The six chapters—omitting the first and last—might form the basis of the thinking of a group through Lent and form the intellectual preparation for Easter worship, though I should suggest that a more leisurely discussion would prove more profitable.

I must express gratitude, first and foremost, to a teacher from whom I have learned more about true religion and theology than from anyone else alive or dead—the Rev. Dr. W. Russell Maltby. His pamphlet *The Meaning of the Cross* took me further than half a dozen books I had laboriously studied just after leaving college, and his later book *Christ and His Cross* is, in my opinion, far and away the best exposition of the Atonement that I have ever read. Here at last I found a preacher of scholarly mind who, having read the opinions of others, gave us his own and went on where others stop. I wanted even his book to go a little further still. If it is not presumptuous to say so, I have

sought to go further in this book. If I have blundered, that is my fault. If I have in any way succeeded, it is largely because of the inspiration I have derived from this beloved teacher.

I would also mention the work of another friend, a theologian of international fame, the Rev. Dr. Vincent Taylor, principal of Wesley College, Headingly, Leeds. He has now completed a trilogy: *Jesus and His Sacrifice, The Atonement in New Testament Teaching,* and *Forgiveness and Reconciliation.* In the closing chapter of his last book Dr. Taylor writes, "The test of a theology is the extent to which, after full investigation, it permits us to describe the Gospel." I am most grateful to these two writers. This represents my main indebtedness. Other books which have contributed to my thought are mentioned in footnotes throughout.

My wife, who has read through the manuscripts of all my books and given me the help of her spiritual insight, has read this and made helpful comments. I am again deeply indebted to my secretary, Miss Winifred Haddon, for unstinted help in preparing this book for the press. Much of the typing and retyping was done by her in circumstances of physical peril, when Hitler's flying bombs were both a daily and a nightly terror. London in the summer of 1944 was no picnic for anyone. Those who had concentrated work to do and who did it are entitled to a special tribute of praise.

LESLIE D. WEATHERHEAD

The City Temple, London

Contents

CONTENTS

The Argument

CHAPTER I expresses dissatisfaction in that the meaning of the Cross for the modern, ordinary man is not made clear in any theological books. Many are of immense value, but are too scholarly for the plain man. Further, they tend to expound the views of Paul, John, the early church fathers, and so on, but don't answer the questions the plain man asks, such as:

1. How can the death of Christ two thousand years ago do anything about my sins today?
2. How can another person bear my sins, for my sins are myself?
3. How does Jesus "take away the sins of the world"?
4. How could Jesus be *punished* for my sins by his Father, when he was doing his Father's will?
5. Men say that "Jesus saved the world," but from what? If a child is sorry, his father forgives without asking for someone else to suffer. Men say that the Cross is necessary to God's forgiveness, but Jesus forgave men before the Cross took place.
6. How can one explain Christ's shrinking from the Cross? Men are repelled by the old-fashioned emphasis on blood; and, as far as I know, no attempt has been made to put the matter in a way which will compel men's belief today.

CHAPTER II: It would seem a good place to begin with the historical facts. What were the factors in the historical situation which impelled Jesus inevitably toward the Cross and made it impossible for him to escape the Cross except by running away? In this chapter we watch the Pharisees and

scribes, the crowds, the close followers of Jesus, hardening against him; and we see in the mind of Jesus himself a change in regard to his destiny and mission.

CHAPTER III seeks to expound the words which Jesus himself used about his passion. Surely this must be the strongest evidence for a right conclusion, and we find that his words reveal that he willingly committed himself to some mighty task, costly to him beyond our imagining, but effecting for men a deliverance beyond their own compassing; and we find that in so doing Jesus knew himself to be utterly one with the will of God.

CHAPTER IV: We ask what this mighty task was and reach the conclusion that it was to bring the whole of humanity— past, present, and future—into harmony with the will of God.

CHAPTER V turns aside in order to note the important historical theories which have sought to interpret the mighty task to which Jesus committed himself. We note the truth that exists in all the theories, but we note also how unsatisfying to the mind of the modern man they all are. They use a verbal coinage which is no longer current, and the plain man doesn't know how to exchange them for the mental coinage of the country in which his mind lives.

CHAPTER VI gets down to the positive task and is entitled "The Cost of Our Deliverance"; and we note the importance for all theories of asserting Christ's divinity, of realizing his union with humanity and his continued ministry after the Cross. In other words, we realize that the meaning of the Cross cannot be understood by taking into account only the historical occasion. If his death had been the end, then the

Cross itself, without his subsequent ministry, would not have achieved man's salvation. It is Christ's endless commitment of himself to us—of which the Cross is the symbol—which is the real energizing dynamic of the salvation of the world.

CHAPTER VII deals with the well-worn phrases "justified by faith" and "saved by his blood," and seeks to put their messages in modern form.

CHAPTER VIII, the Epilogue, aims at comforting those who find it hard to understand by reminding them that, even more than understanding, *faith* is the means by which we appropriate all the "benefits of his passion."

CHAPTER I

Dissatisfaction

THOSE who expect to find in this book a complete and satisfying exposition of all that the death of Christ means for the individual and for the world had better lay it down at once. Such a task is certainly beyond the competence of the author. Indeed, I cannot imagine any author, however great his scholarship or penetrating his spiritual insight, getting to the point where he felt he could so expound the message of the Cross as to leave no question unanswered and nothing unexplained.

In some moods—the mood, for example, in which I find myself on each Good Friday morning—one feels it almost a sacrilege to argue and to discuss. One desires then only to bow in adoration before the mystery of a love whose depths no one can sound and the range of whose august purposes is like that of a shooting star. It sweeps in from the Infinite and the Unknown, and comes near enough to earth so that we may see something of its shining glory. We watch with awe and wonder; but when all that can be seen by human eyes has passed into the darkness, and a cry is heard, "It is finished," we still know that a purpose goes on, beyond our vision, in the Infinite and the Unknown, and we cannot even imagine its scope or guess at its goal.

Incarnation, Crucifixion, Resurrection, Ascension—easy words to write. But what went before the Incarnation, and what goes on after the Ascension? The life and passion, the death and resurrection of Jesus were seen of men. The Star came near enough to be seen; and, like many a heavenly body that comes near the earth, its form was consumed in doing so. So he came from the Infinite and burned out his human form in blazing love for men; but undiminished, untouched in essence, he returned beyond our power to follow him, to continue his agelong ministry of redemption—"very God of very God, . . . who for us men and for our salvation came down from heaven." So began a breath-taking drama of significance for all individuals of every age and every clime, a drama played out on the humble little stage of an unimportant country at the eastern end of the Mediterranean Sea nearly two thousand years ago, a drama which we call "The Redemption of the World by Our Lord Jesus Christ."

The view that is set forth in the following chapters, incomplete as it is bound to be, is the result of my own mental and spiritual need. Nearly thirty years ago I left Richmond College, one of the theological schools of London University, to begin my life work, which I then thought would be that of a missionary in India. But concerning the Cross —stated by everyone, and most emphatically by every New Testament writer, to be the central doctrine of Christianity—I felt I had little faith and less understanding. The man Christ Jesus as a hero to be followed, the risen man as an ever-present friend, provided themes in which I felt much more at home. There was no lack of sermon material for a young, keen preacher. But I realized that more than

half of Mark's Gospel is taken up with the incidents of the passion, not the incidents of the ministry, of Jesus, and that the message which the apostles offered to a pagan world was not so much a message about his teaching and life as a message about his death and resurrection. One might make attractive, convincing, and even converting sermons about the life of Jesus as exhibited in the incidents of the first half of his ministry; but that great Christian warrior Paul, facing an indifferent and often hostile crowd, did not fight with this weapon at all, it would seem. One would think that a disciple would lay the greatest emphasis on his Master's teaching; but, so far from doing this, Paul hardly quoted him at all. His message was not about what Jesus taught. It was about his death and resurrection and endless ministry. Again and again his theme was: "Christ died for our sins according to the scriptures"; "Him who knew no sin he made to be sin on our behalf"; "Christ Jesus, who gave himself a ransom for all"; "He died for all"; "Christ redeemed us from the curse of the law, having become a curse for us." [1] Every student of the New Testament could multiply the passages in that strain; and no honest student of the New Testament could deny that the message of the early church which turned the world upside down was a message, not about one who healed the sick, preached thrilling sermons full of new and revolutionary ideas, discoursed on lilies and birds, made friends with publicans— glorious as all these messages were and are—but about one who died and rose again, and ever liveth to do something vital for us and in us.

This fact worried me, as, frankly, it worries many

[1] I Cor. 15:3; II Cor. 5:21; I Tim. 2:5-6; II Cor. 5:15; Gal. 3:13.

preachers. One can disguise this worry and effectively hide it. One can find some kind of sermon for Good Friday. But, to be honest, I did not know what the sentence, "Christ died for our sins," really meant; and if the reader is shocked, I would ask him to close this book immediately and try to explain to a schoolboy or schoolgirl of fifteen— and all our messages ought to be understandable by such— exactly what is meant, in plain English, by the sentence, "Christ died for our sins."

Like the rest of my classmates at college, I knew the scripture passages that bear on the Atonement, as it is called. I knew the "theories of the Atonement" which seek to "explain" the Cross. I had on my shelves Dale and Denney, Forsyth and Moberly, Scott Lidgett and Mozley. But part of my trouble was that these great theological writers finished just where I wanted someone to begin. They dealt faithfully with Paul's contribution. They had a chapter on the Johannine writings. They examined the Epistle to the Hebrews. The views of Origen, Augustine, Athanasius, Anselm and Aquinas, and other scholars and fathers were examined, and so on. But though, with difficulty, I could follow what was being said, the light did not shine. There was not that exhilarating sense of mental freedom and inward illumination which comes when truth is perceived, when we not so much grasp truth as find that it has invaded us and taken possession of us, and we know that something as mysterious and wonderful as birth has taken place within us. Something of our very own is born within us. The universal becomes intimately personal, and truth is not only something which gains our outward assent; it is something that has become part of ourselves for evermore. Therein is

24

the difference between acquiescence and belief. The aim of preaching lies, we may say in parenthesis, not in telling people what they don't know, but in getting them to *believe* and *see* that to which they may only have assented.

No truth in the world, however strongly commended to us, however imposing the authority behind it, including the authority even of the Bible or of our Lord himself, has much value to personality until it can win such a response. This is true in other realms besides that of truth. We may be told a piece of classical music is grand and wonderful, and insincere people hearing it in a lady's drawing room clasp their hands with simulated delight because their hostess says it is marvelous. But it has little value as music to the listener unless his whole being is invaded by it and possessed by it, in which case he will probably make no gushing reply at all, but remain silent. Incidentally, just as truth often has to be repeated and repeated and repeated before it dawns with its transfiguring light upon the soul, so a musical composition has frequently to be heard again and again and again before even the musical listener really possesses it. In a similar way one has seen people gathered in front of a picture in an art gallery because somebody says it is "famous" or "wonderful"; and stupid, superficial people will be heard vaporing about its merits merely because they are affecting a pose of being connoisseurs. The picture has no value as beauty unless it possesses the soul of the beholder and he makes a sincere response—a response which cannot be coerced or compelled or forced by any authority in the world. All that authority can do, in default of the response that is born within the beholder, is either to make him admit that he sees nothing in the picture

or else to make him be insincere and simulate the pleasure which he feels the authority wishes him to feel. In the same way it is all very well for the theologians, and even the New Testament writers, to tell us that the Cross is the central message of Christianity; but if the truth is not put to us in such a way that we possess it ourselves, no weight of authority can make it a living thing in our own hearts, a living message we can give to others, or a means by which our souls are fed.

Authority can do one important thing in regard to a message, and the success of the message in winning simple people can reinforce the authority. Both make us say, as a man might say of a great musical composition or a picture, "There *must* be something in all this, and I'm going on until I find it." But do let us be sincere in our "going on" and not pretend that the Cross has a central message if that message has never captured our personality, if the forms in which it has been presented to us leave us cold and unconvinced.

Much theological writing on the great doctrines of our faith deserves the shrewd comment which Mr. C. S. Lewis makes upon it via *The Screwtape Letters*:

The Historical Point of View, put briefly, means that when a learned man is presented with any statement in an ancient author, the one question he never asks is whether it is true. He asks who influenced the ancient writer, and how far the statement is consistent with what he said in other books, and what phase in the writer's development, or in the general history of thought, it illustrates, and how it affected later writers, and how often it has been misunderstood (specially by the learned man's own colleagues) and what the general course of crit-

icism on it has been for the last ten years, and what is the "present state of the question." [2]

No wonder the man in the street finds it hard to understand theology; and yet, to some of us, it is the most fascinating of all subjects. But first the theologian usually takes the reader roundabout ways, via Anselm and Aquinas. He uses words which belong to another world of ideas than that of most readers, and few members of the general public can find their way through a book of theology. We need more writers who can translate the language of the scholars into the language of the busman or the milkman. I knew a milkman who was a most intelligent man. He was invalided out of the army, and discovered in himself a great love of books of travel, which I rejoiced to lend him. But having visited him when he was ill and spoken with him on this matter, I found that if I used the word "atonement," or "incarnation," or "redemption," or "salvation," or "justification," or "propitiation," or "oblation," or "expiation," he did not know what I was talking about. Yet any scholarly book on the Cross teems with terms of this kind. Be honest, my dear reader, and ask yourself whether these terms are current coin in the mental country in which *you* live! Surely there is a place for a book which, while paying a deep tribute to the theological ideas of ancient writers from Paul onward, longs to express the meaning of the Cross in terms that, by taking a little trouble, a plain man can understand.

Unfortunately, not only does the theologian use words which belong to a vocabulary only the theological student can understand; he uses words in a sense other than their

[2] P. 139. By permission of The Macmillan Co.

apparent meaning. For example, the word "propitiation" really means an act or ceremony by which the anger of the god is bought off by some kind of sacrifice or blood offering. Yet it is used every Sunday in the Communion Service attended by plain men and women. On the other hand, some words, like the word "grace," are used so loosely that they come to have no meaning at all. They win no response from the reader, and one sometimes wonders whether they were seriously intended to do so by the writer.

In my own search for the meaning of the Cross I wanted to find a book with at least one chapter headed thus: "The Significance of the Cross for the Modern Man." After all, Paul attempted this task for his generation. He had to make sense of what from the human side was a ghastly crime. Such a making sense was his theory of the Atonement. Being an Eastern Jew with the traditions of the Jews behind him, familiar as he was with the practice of offering up on the altar the body of an animal, he naturally interpreted the Cross in terms of the age-old Jewish sacrifices. It was not only natural but inevitable, and it was cogent for all those who believed in Jewish sacrifices and felt that they enshrined an important truth. Hundreds of times in olden days he had seen lambs sacrificed as sin offerings, so that the offerer could obtain freedom from the burden of sin. Had not Jesus himself been called "the Lamb of God"? [3] The meaning of the Cross to Paul became crystal clear—to Paul, but not to us. [4]

[3] John 1:29. I realize that the evidence of this isolated text is not to be pushed too far, and that the Fourth Gospel appeared late, but the *idea* may have been an earlier one.

[4] I realize that to state Paul's theory of the Atonement so crudely is to do him less than justice. "Let us carefully observe," says Principal

The writer of the Epistle to the Hebrews followed in the same way, using the same thought forms: "Apart from shedding of blood there is no remission." [5] And again: "For the bodies of the animals whose blood is taken into the holy Place by the high priest as a sin-offering, are burned outside the camp; and so Jesus also suffered outside the gate, in order to sanctify the people by his own blood." [6] And again: "If the blood of goats and bulls, and the ashes of a heifer sprinkling them that have been defiled, sanctify unto the cleanness of the flesh: how much more shall the blood of Christ, who through the eternal Spirit offered himself without blemish unto God, cleanse your conscience from dead works to serve the living God?" [7]

Exactly! But then I don't believe the blood of goats and bulls does anything. No more, my dear reader, do you! So the whole argument falls to the ground. It is not the way of approach that takes us furthest today. We are not Eastern Jews. It is not that we can, or think we can, see further than Paul. That would indeed be a grotesque presumption. But the Master himself said that the first and greatest commandment is to love the Lord our God with all our mind.[8] It is not loving God with your mind to try to take over an

McCrea, "that St. Paul never said that God punished Christ, or that Christ stood as a substitute bearing the penalties due to all mankind in infinite woe in Himself. Such utterances have gone beyond what is written in St. Paul." (*The Work of Jesus in Christian Thought*, p. 95.) But the plain man reading the Pauline epistles deduces that Paul's theory of the Atonement is roughly as I have stated it. "The vicarious suffering of Christ was the way by which sin could be borne and sinners reconciled to God." Cf. Eph. 5:2.

[5] Heb. 9:22.
[6] Heb. 13:11-12 (Moffatt).
[7] Heb. 9:13-14.
[8] Matt. 22:37.

ancient and Eastern figure of speech if it obscures the truth rather than reveals it, and if it not only bewilders but repels the minds of those you are seeking to help.

What we need, as I see it, is not so much a commentary on what Paul meant—that has been done by far abler pens than mine, and even then has failed to bring intellectual satisfaction—but an attempt to do what he did so admirably for his own generation, an attempt to throw light on the mystery of the Cross by using the metaphors, thought forms, and illustrations which are acceptable to the modern mind. Ways of interpreting the Cross have now hardened and crystallized into the historical theories we had to learn about at college, largely because Paul and successive interpreters could no more escape from their particular thought forms than we can. After all, the message of Jesus Christ, both as it was preached and as it was revealed in his living and dying, his resurrection and subsequent ministry, was so devastatingly new, and the spiritual achievement which we call the redemption of the world—leaving for the moment what that phrase means—was so shattering to men's old, habitual ways of thinking, that there were no words or thought forms or metaphors in existence big enough to carry the new message. It is not surprising, therefore, that for very shelter men crept back into the old, familiar structure of Jewish ideas about sin offerings made in the temple; and from this prison—for it is a prison to modern Western thought—few even now have escaped.

For myself, I could state my own faith in the Cross by saying, "Christ died for our sins," but I have had to tread another and different thought road to get there. And we should not, I think, be put off from this attempt at restate-

ment by the certainty of failure. The tremendous truth cannot be put completely into any language. It "breaks through language and escapes." But if, by using modern metaphors, we can get a bit nearer, let us do so. Understanding immensely assists faith, and though the understanding will remain partial, if it assists faith it is worth while. And, after all, every new generation is free to restate essential religious teaching in its own metaphors and thought forms. We do not queer anyone else's pitch by making our own attempt.

Evidence of the unsuitability of some thought forms today is found, if we need it, in the hymns which are still sung by many.

> There is a fountain filled with blood,
> Drawn from Immanuel's veins;
> And sinners, plunged beneath that flood,
> Lose all their guilty stains.

Such a verse becomes hallowed by associated memories. My own mother sang that hymn with sincerity, but to an imaginative and sensitive mind unfamiliar with those associations the verse just quoted suggests a most repellent picture. Not that the modern mind is "nice" and "refined." Many moderns have seen plenty of human blood shed, and they know they deserve to be called "sinners." But the picture is not the one which gets some of us closest to the truth.

The hymn,

> Wash me in the blood of the Lamb,
> And I shall be whiter than snow,

used to be heard frequently in certain congregations, and the phrases run back to the book of Revelation.[9] But as long ago as the last war, men in my regiment sang a parody on it to cheer themselves during a long route march in the desert. It would do no good to quote the ribald words; but, in contrast, men showed the deepest respect for hymns like "When I survey the wondrous Cross."

I am thinking, as I write, of some of the men and women in their early twenties, not too many of whom come to church. They are all educated. They nearly all love poetry and beauty and meaningfulness of expression. What *are* they to make of some of the hymns in most hymnbooks? I fully expect some honored and friendly Salvationist or dear old Methodist will expostulate with me and tell me about the old days. But I want to win the splendid youngsters of the new days so that they will listen to and receive the good news about the Cross, which during the last few years has awed and captured my own mind and heart, binding me with the spell of what is undoubtedly the most amazing truth in the world.

> Not all the blood of beasts,
> On Jewish altars slain,
> Could give the guilty conscience peace,
> Or wash away the stain.
>
> But Christ, the heavenly Lamb,
> Takes all our sins away;
> A sacrifice of nobler name
> And richer blood than they.

That's a bit better, but what is a youngster fresh from boarding school, or a science student working in a uni-

[9] Rev. 7:14.

32

versity laboratory, to make of that? I am not being derisive or trying to be superior or squeamish or anything foolish like that, but I want to write something that would have helped me immensely if I could have read it thirty years ago. I did write a long and careful letter to my college tutors. Two of them sent me lists of books about the death of Christ. I got them and read them, but none of them gave me a view of the Cross which possessed my mind in the way I have described. None of them answered the insistent questions which rose continually in my mind, prompted, I sincerely believe, by a sincere quest for truth, a quest which clamored for, but did not receive, a satisfying reply.

Let me set those questions down here quite bluntly. At the end of the book the reader may test its value by turning back to them and asking himself whether they have been answered.

1. How can the death of a man two thousand years ago have anything to do with my sins today, and the sins I have not committed yet?

2. How can another person bear my sins? If I did them, and do them, I am guilty of the doing. Isn't it a fiction to sing, "I lay my sins on Jesus"?

3. How does Jesus "take away the sins of the world"? The sins of the world remain to blight and curse the earth. My sin is not a burden someone else can bear, or a debt someone else can pay. My sins have become myself. The habit tracks of my mind, even the molecules of my brain, are affected. "I won't count this time," says the sinner after each new fall. Says William James, the psychologist, "He may not count it, and a kind heaven may not count it, but it is being counted, just the same. Down among his nerve

cells and fibres the molecules are counting it, registering, storing it up to be used against him when the next temptation comes." How can a death so long ago do anything about that?

4. How can Christ be thought of as *punished* for my sins as if he stood in my place and were sentenced by a judge? Surely the judge was his Father, whose beloved Son was carrying out the Father's will. It is not just to punish one for the sins of another, especially to punish one for doing what you willed him to do. One of our hymns says:

> Bearing shame and scoffing rude,
> In my place condemned he stood.

But how could he be *condemned* for something he had not done?

5. Men say that "Jesus saved the world," but from what? Not from sin, for that abounds. Do they mean that the whole human race would have been condemned in an endless hell if Jesus had not been nailed to the Cross? Do they mean that even one sinner would have gone to endless hell if Jesus had not died? The hymn above quoted goes on to say that he "sealed my pardon with his blood." But does that mean I could not be forgiven without it? If my child "sins" against me, I do not demand somebody's blood as an "atonement." I do not demand that somebody else should suffer for it, as though every sin had an equivalent measure of pain and could be forgiven only if such pain were borne by somebody.[10] I agree that forgiveness is impossible without repentance, but with repentance what hinders immediate forgiveness? Is it implied that God could not forgive

[10] Note the line in an earlier hymn: "Exacted is the legal pain."

anybody unless this brutal and bloody murder was committed as a "satisfaction"? That does not satisfy the eternal law of righteousness they talk about. It affronts it. Some people insist that the Cross is necessary to forgiveness, but in the days of his flesh Jesus forgave men before the Cross had happened at all. His blood had not been shed, but were these men not at one with him? And when the psalmist cried, "As far as the east is from the west, so far hath he removed our transgressions from us," [11] was this all bluff because Jesus had not died?

6. Thousands of people have suffered greater pain than Christ and over longer periods, but they have not agonized to be let off it or gone to it with such shuddering. Many of the early Christian martyrs were crucified singing songs of praise to Christ himself. How can one explain Christ's shrinking from the Cross: "O my Father, if it be possible, let this cup pass away from me"? [12]

I have written down these questions crudely, even brutally, but these are the questions people ask. Therefore these are the questions we ought to try to answer, and it is no good fobbing people off by a repetition of words which, however sacred, actually mean nothing to their minds at all. The phrase, "Christ died for our sins," is for most people in that category.

A thoughtful businessman told me recently that he had "put down all my sins at the foot of the Cross." When I asked him exactly what that meant, he became vague and woolly and said he just had faith. But it was a faith he couldn't defend. The last thing I want to do is to arouse

[11] Ps. 103:12.
[12] Matt. 26:39.

35

questions in minds that ask none and can just "have faith." But from private letters and conversations through many years I am quite sure that many people do ask questions, and that if our answers satisfied them, or got anywhere near doing so, their faith would be strengthened. In some cases faith in Christ's redemptive work is waiting to be born for lack of understanding.

What I want to do, then, in this book is as follows. Let it be realized that a Jewish thinker, like Paul or John, with the historical facts before him which led up to the death of Christ, could only sit down and try to make sense of it all by using the metaphors and thought forms which were real and meaningful to him and to his listeners and readers. Hence the view of the Cross which we find in the New Testament, passed on thence through sermons and books and poems down to the hymns which we still sing.

· Let us pay a tribute to the learning and devotion of these great writers; but, even though we are further from the facts and have but small intellectual equipment for the task, let us humbly and reverently claim the same privilege as they. Let us not try to take over the interpretations which they gave, as though that were the only path to mental helpfulness and spiritual belief. Let us not be forever imprisoned in thought forms which appealed to earlier generations. Let us, loving God with our own modern minds, go back to the gospel language and the historical records, not indeed as trained theologians using a particular nomenclature, but as ardent, if simple, disciples, longing to enter, as far as may be, into the mystery of the central event in the world's history. Let us look at the Cross and try to find an interpretation which satisfies Western minds in our own day.

We may read with superior feelings the sentence which Paul wrote to the Corinthians, to the effect that the preaching of the Cross was to the Greeks foolishness; [13] but, frankly, to most moderns it is meaninglessness, and however ardently men may wish to "believe," the Cross will remain meaningless unless it can be—to repeat a monetary metaphor—changed into the verbal coinage that is current in the mental country through which the mind of modern man is now traveling.

I was delighted—and, I must admit, surprised—to find my friend, Dr. W. R. Matthews, the present Dean of St. Paul's Cathedral, writing as follows: "We need to get clear on the point that no doctrine of the Atonement is part of the Christian faith and that many different views are possible concerning the manner of the Divine forgiveness. The one thing needful is the faith in the fact that God does forgive sinners. After all, our supreme Authority is not Luther or Augustine, or even St. Paul, but Christ." [14] Let us look, then, at him and at those events which brought him to the Cross.

[13] I Cor. 1:23.
[14] *Seven Words*, p. 29.

CHAPTER II

How Jesus Came to His Cross

I WANT the reader at this point to detach from his mind and leave out of account all the theories of the Atonement that scholarly theologians have made, whether deduced from the gospel narratives or from the writings of Paul. I want him for the moment to go even further and divest his mind, for the time being, of views about the character of Christ—the view, for instance, that he was divine. I believe in his divinity most intensely, but I want in this chapter, as nearly as possible, to watch him through the eyes of those who were with him, and who, *at that point*, had not come to a conclusion about divinity. I want the reader, in imagination and in detached mood, to watch events happening in Palestine without having made up his mind beforehand what they mean, and what theories they are alleged to support.

This, then, is what we should see. In the obscure setting of a carpenter's shop in Nazareth, we should watch a young man vibrantly alive. He is like the other young men of the village in many ways. Yet he is unlike them. Religion is a passion with him. He spends hours with the local rabbi discussing the sacred law, poring over the sacred manuscripts which now we call the Old Testament. The old prophets fascinate him. The Psalms he knows by heart.

Moreover, he spends hours in solitary walks, and sometimes the whole night long he will meditate in

> The silence that is in the starry sky,
> The peace that is amongst the lonely hills.

Yet he is not a morbid or melancholy young man. On the contrary, he has a radiant gladness about him that makes everyone attracted to him. Children adore him. He loves to go on picnics with them and tell them stories. He likes a jolly feast too, and has quite a name for being the "life and soul of the party."

In course of time, with others, he is baptized in the river Jordan by his cousin, John the Baptist, who is conducting a mission of repentance, similar to many conducted in the older days of Israel's history. Here we note an important difference between Jesus and others whom John baptized, but it is a difference the significance of which was probably read into the facts long after their occurrence. Only Matthew reports John's diffidence in baptizing Jesus,[1] and only in the Fourth Gospel, written perhaps as late as A.D. 120, is it reported that the Baptist called Jesus the "Lamb of God."[2] The dove and the voice describe Jesus' inner experience, I think, which he disclosed later. There is no evidence that anyone but he saw a dove or heard a voice. "The heavens were opened unto *him*, and *he* saw the Spirit of God descending as a dove."[3]

For more than a month this young teacher is away from the sight and sound of men, in the grim desert between Jerusalem and Jericho. Afterward, in a form they could

[1] Matt. 3:14.
[2] John 1:29.
[3] Matt. 3:16; cf. Mark 1:10; Luke 3:22.

understand, he gave them the gist of the inner conflict which, during those days of prayer and fasting, raged within his breast. He knew he had a message about God which it was vital men should hear. Therefore it was of the first importance that he should catch their ear and gain their attention. There was little likelihood that they would listen to a carpenter's son. Indeed, the Gospel confirms how right Jesus was in this assessment of their attitude. "Is not this the carpenter's son?" [4] they said with scorn. How *could* he make them hear? Supposing he used the power he had to raise the standard of living and end their economic anxiety. A movement to provide bread would make them listen. Indeed, no *movement* was necessary; a miracle would do it. He knew he had miraculous power. They asked for bread. How could he give them spiritual teaching, which, while their stomachs were empty, they would regard as stones? Who wants to listen to sermons, or even stories, while his children are starving? No, bread came first. He would work a miracle, or initiate a movement to provide a better standard of living. If he gave them bread, they might listen. After all, God meant them to have bread. How could he talk of the love of God to the starving?

Rejecting that as a way of buying men's allegiance with bread, he considered men's love of the spectacular. If he used sensational methods and floated down from a pinnacle of the temple, they would listen. Children, young and old, love a conjurer. Besides, it had been rumored in many a legend that thus would the Messiah come. And God's angels would protect him lest he "dash his foot against a stone." Magic might open the door to messages he longed

4 Matt. 13:55.

40

to introduce. But he put that aside too. Only when stern duty demands is one allowed to put God to the test. This wasn't duty. It was a temptation to take a short cut to "prove" that God would support him *whatever he did*. No one has the right to make trial of God in that spirit. "Thou shalt not tempt [make trial of, or test] the Lord thy God." [5] No, not even the Son may do that. "The Son can do nothing of himself, but what he seeth the Father doing." [6] And the Son had never thus regarded his Father's work.

There was one other certain way of being heard in his day. The whole country seethed with hatred against Rome, the invader and oppressor. If he led a revolt, a thousand swords would flash from their uneasy scabbards in his support. To free his own dear land, to reign over all nations in the name of God, to teach them then the message that burned in his breast—surely that would do two things in one. The age-old dreams of Israel would come true in the way the people wanted them to come true, and surely every heart would receive his message of a spiritual kingdom if, first, the material one was secured.

But, as he reviewed the various short cuts to popularity, he recognized them all as a misuse of the power God had entrusted to him. It is the essence of power that it is ability to achieve purpose. And God's purpose, with which he utterly identified himself, was to win man, not by bribes or the display of overwhelming power, or by any means which drug the personality or disable the mind, but by man's free choice. Therefore to weight the balance of

[5] Matt. 4:7.
[6] John 5:19.

41

man's choosing with the bait of bread, or the lure of magic, or the attractiveness of a political revolution aimed at over-throwing Rome, would so defeat God's purpose as to prove an expression not of power but of weakness, a weakness which dared not refrain from loading the dice of human choice.

So he returned to the disciples and, without excitement and publicity at first, as a wandering teacher "went about doing good" and "preaching the good news of the king-dom."

"And he could not be hid." [7] Healing disease by a touch cannot leave a man in obscurity. Confounding the Pharisees on their own topic—religion—and charging them with hy-pocrisy is sure to bring a man into the headlines, or their first-century equivalent. Living a life of such vital spiritual quality and such attractive power that a customs officer will leave his desk, and fishermen leave their nets, makes even the stolid take notice. And when masses of ordinary people trudge across a desert to listen to his voice, a man is bound to be in the limelight. "All are seeking thee," [8] the disciples told him. "They had no leisure so much as to eat," [9] we read. No wonder. If it were possible to find him, to see him in the flesh and hear his voice, we should all want to make a pilgrimage. He had caught the ear of the people all right. There was no need for a revolution, economic or military. He could not move without the crowds following him about.

I do not deduce, as I read and ponder the gospel story,

[7] Mark 7:24.
[8] Mark 1:37.
[9] Mark 6:31.

that Jesus in those days of his early ministry contemplated his death at all, though of course it is possible that he referred to it. We may remember, moreover, that his mind was truly human and as far as may be from being morbid. Young, active men in the thrill of an early ministry in which they exult, and with a blazing message they delight to deliver, do not think about their death. Jesus rejoiced in his message. He thanked God for the chance to declare it. Multitudes listened. It wasn't hard to get a crowd. "The common people heard him gladly." [10] It was such a glorious message, how could they do anything else? God was the Father of all men. All men were brothers. Nothing was needed so much as a new relationship between man and God, and between man and his fellow man. From that, all they desired would flow. They could even win the friendship and co-operation of Rome. [11] Heathen nations would ultimately come into the scheme. [12] The whole world, through the leaven of a changed Israel, would be the conscious family of God in a world in which all necessities were provided by God and would be shared among men. [13] The kingdom of heaven would be seen on earth. That was the good news. That was God's plan. Let them repent, for that was their first task. Let them "change their way of looking at life and believe the good news." [14]

In those early days I don't think Jesus had any thought that men would fail to react rightly to a message which so obviously both came from God and, if carried out, would

[10] Mark 12:37.
[11] Matt. 5:40 ff.
[12] Luke 13:29.
[13] Matt. 6:33.
[14] Mark 1:14.

spell blessedness for themselves. The leaven of his teaching would spread through mankind until the lump was leavened and all mankind became the conscious, happy family of God.

But as one goes on reading the gospel narratives, a dark shadow begins to creep across that sunny blue sky. No! There is a greater urgency than that figure suggests. We feel like men who watch, with growing alarm, a tragic play on the stage. We are so moved that it is only with difficulty we can restrain ourselves from rising in our seats and shouting a warning to the hero that something has gone wrong. But the hero in this tragedy needs no warning. "He himself knew what was in man." [15] He knew what was going on.

Let us look first into the minds of the scribes and Pharisees. Second, let us look into the minds of the crowds. Third, let us watch the changing color of the minds of the disciples. Fourth, let us reverently seek to look into the mind of Jesus.

First we watch the Pharisees and scribes plotting to entrap him. They seek to "ensnare him in his talk." [16] Why, what has he done to them? What has he done? What has he not done? In Dr. Gore's phrase, "He has challenged the Pharisees to change their fundamental ideas and methods in matters of religion; and when have high ecclesiastics been ready to accept this challenge from a 'mere layman'?" [17] If Jesus is right, they are wrong. If Jesus is proved right, they are proved wrong. If Jesus wins the people to

[15] John 2:25.
[16] Matt. 22:15.
[17] *Jesus of Nazareth*, p. 169.

his side, their job is done, their influence has gone, their prestige vanished. That *they* should repent probably occurred to only a few like Nicodemus and Joseph of Arimathea. Besides, their very living was threatened. Josephus says that twenty thousand priests ministered in the temple. Some would serve in the temple for only one week in the year, but would take a full year's wages. To Roman taxes, priestly taxes were added. Annas and Caiaphas controlled not only taxation, but the temple market. They had country estates on which the animals sacrificed in the temple were raised. All other animals were rejected. All other sales were prohibited. They determined the rate of exchange. Their avarice, corruption, luxury, gluttony, and oppression were a byword among the people.[18]

Are they going to change their way of looking at life? Are they going to become as little children? Is there any chance of their becoming meek and lowly in heart? Not they! Men love darkness rather than light because their deeds are evil. The scribes and Pharisees worked in the dark; they kept the people in the dark. Light is the enemy of darkness. Light "showed them up," as we say. They must extinguish the light at all costs, and the quicker the better. They are afraid of him. No wonder! Some of them have seen his supernatural deeds as he goes about his Father's business. They are afraid of what the people will do to them if they touch him yet. But listen to what they say. "If we let him thus alone, all men will believe on him: and the Romans will come and take away both our place and our nation." [19] What a tribute that is to him from the

[18] Basil Mathews, *A Life of Jesus*, p. 349.
[19] John 11:48.

mouths of his enemies, and what impressive evidence of the view expressed above that he himself expected to be believed in and followed, not rejected.

Then watch what his enemies do. Led by Caiaphas, the arch fiend of the tragedy of the Passion, they withdraw into dark corners and, with devilish cunning, weave the net of a plot, making it stronger and stronger, until, thrown quickly—even clumsily—it is strong enough to bring him down.[20] The speed of events at the end, the illegal trial at dead of night, the employment of Judas, show how afraid they were that Jesus would head a revolt, perhaps even using supernatural power. But "their voices prevailed," and Jesus was crucified.

Second, note the change in the crowds. They loved his preaching, delighted in his miracles, gloried in restored health, believed in his messiahship in their own way. But they had not—what crowd has?—the moral stamina to stand by him when his way was not their way. Theirs meant swords flashing, banners flying, revolt against Rome, Jewry reinstated in power. A voice cannot be popular with the crowd when it stabs at men's moral iniquities and dismisses as irrelevant their popular hopes. So they began to change their minds about him.

Third, watch the disciples and the close followers of Jesus. What full, happy lives they must have lived with Jesus at the beginning! "We have been out of port for many weeks," wrote another hero-worshiper later, *but we are with Nelson.*" True the disciples had "left all," but they had found the Messiah. They too went out preaching this

[20] The clever cunning of this plot I have described in the chapter on "Caiaphas" in *Personalities of the Passion.*

46

glorious gospel. They too had the delirious joy of miraculous cure. They came to Jesus bubbling over—"Even the devils are subject unto us in thy name." He had to warn them against pride, they were so "set up with themselves"— "I beheld Satan fallen as lightning from heaven." [21]

But look into their minds. There is little doubt that they thought he was the Messiah *in their sense*. The kingdom to them was not a kingdom of right relationships, especially with Rome. Rome was to be "liquidated," Caesar's grip on their beloved land broken. They were to rule. They quarreled as to who should be first and which should sit to left and right of the King himself. They were actually quarreling about this on the way to the Upper Room on the night before his death. They took the words of Jesus that bolstered up their own ideas and comforted themselves with them. The other words, the words that didn't fit *their* ideas, they left out—just as we do.

As the things they wanted receded, and the things they didn't want drew nearer, as the dark cloud spread across the blue sky, as the play moved relentlessly toward its tragic end, some of them went home: "Many of his disciples went back, and walked no more with him. . . . Would ye also go away?" "They all left him, and fled." [22] How sad the revealing words seem now!

But, fourth, Jesus changed too. This, to some, will seem a bold and unorthodox thing to say. I fear it may offend some. Let us consider it:

1. *There was a change in the mind of Jesus.* Surely the true humanity of Jesus would demand that the ways of

[21] Luke 10:17, 18.
[22] John 6:66-67; Mark 14:50.

God, even to him, should only gradually become known. "He . . . *learned* . . . by the things which he suffered," says the letter to the Hebrews.[23] If all is known at the beginning, there is nothing left to learn. Did not the nights of prayer spent among the mountains mean that the Father was gradually disclosing his mind and will to the beloved Son? Indeed, could a truly human brain and nervous system hold, together with normality, the sudden disclosure of such mighty and demanding plans of God? Jesus himself seems to have answered the question when he said, for example, in regard to the consummation of the age, "Of that day and hour knoweth no one, . . . neither the Son, but the Father only." [24] I have come to feel that Jesus slowly changed his mind. Having set his plans for acceptance, having believed he would be followed, having dreamed he could win a response from men, he saw what the Pharisees were doing, assessed the stupidity of the disciples, weighed events, and, with solemn heart, began to learn from his hours of communion with God that the path he was treading would lead to the Cross, that he would "suffer many things . . . and be killed." [25]

2. *There was a change in the general language of Jesus.* Naturally a change in his own mind would be reflected in a change in his words to others. In the early chapters of the three evangelists, when Jesus was calling his men and teaching them and sending them out on preaching tours, there is no mention of his death, no word about the Cross.[26]

Even when he tells his men that they must take up their

[23] Heb. 5:8.
[24] Matt. 24:36.
[25] Matt. 16:21.
[26] Matt. 1–9; Mark 1–7; Luke 1–8.

cross [27] and follow him, I am not sure that he implied the meaning which we read into the words now. Dr. C. C. Torrey, who has given us a translation of the Gospels based on the Aramaic, which was the language Jesus spoke, says it is unlikely that Jesus would use the word "cross" at this stage in the sense we understand it. He thinks that the crossbar, a wooden beam which was part of the yoke placed across the shoulders of oxen during plowing, is what is meant. "He who will not accept the burden of the crossbar and help pull is not fit to be my disciple," would then be the meaning of the statement. This would be in line with another recorded saying of Jesus, "No man, having put his hand to the plow, and looking back, is fit for the kingdom of God." [28] The idea of bearing the yoke would be easily understood. But only revolutionaries against Rome were crucified. If Jesus had talked about his disciples bearing their crosses and being executed, his language would have strengthened the very idea that he sought to root out, namely that he was about to lead a revolution against Rome and that he called upon his disciples to aid him. [29]

Whether this is so or not, there is, in the gospel narrative, a profound change; and I think its significance has never been sufficiently emphasized.

Just as Jesus went away into the desert to think out his program when he made plans for the *acceptance* of his message, so he went away to the remote region of Tyre to make his plans when it dawned on him that both he himself and his message would be *rejected*. There is the very brief-

[27] Matt. 10:38; 6:24; Mark 8:34; Luke 9:23; 14:27.
[28] Luke 9:62.
[29] So Prof. J. A. Findlay argued in *The British Weekly*, Nov. 25, 1943.

est record. "He arose, and went away," we are told, "into the borders of Tyre and Sidon. And he entered into a house, and would have no man know it; and he could not be hid." [30] He evidently wanted to be alone. He was out of Herod's jurisdiction and thus, for the time being, out of imminent physical danger, in the atmosphere of which it is impossible to think. He was away from scribes and Pharisees, free from the interruption of crowds, to meditate and to pray—Matthew says he "withdrew." [31] And it is with a melancholy sadness that we think of Jesus at the seaside, among the sand hills, walking along the lonely shore in what was a "foreign country," with the shadow of the Cross beginning to fall upon that radiant spirit. We have only the scantiest record of what he did there, [32] but he was there for a long time. Professor Burkitt notes the "green grass" at the feeding of the five thousand and that Jesus was away almost until the Passover. If Mark's chronology can be trusted, Jesus was away for about nine months. He must have made some contact with the people, for he praised them in the rebuke he uttered to Chorazin and Bethsaida: "Woe unto thee, Chorazin! woe unto thee, Bethsaida! for if the mighty works had been done in Tyre and Sidon which were done in you, they would have repented long ago in sackcloth and ashes." [33]

But I have come to believe that the long weeks and months in Tyre were another desert experience of inexpressible loneliness and temptation, of mental turmoil and strife. He returns to the Sea of Galilee and soon after is

[30] Mark 7:24.
[31] Matt. 15:21.
[32] Mark 7:24-31. See *It Happened in Palestine*, pp. 191-204.
[33] Matt. 11:21.

found far in the north at the foot of snow-clad Hermon in the village of Caesarea Philippi.

Who do men say that I am? . . . Peter answereth and saith unto him, Thou art the Christ. And he *charged* them that they should tell no man of him. And he *began* to teach them, that the Son of man must suffer many things, and be rejected by the elders, and the chief priests, and the scribes, and be killed, and after three days rise again. And he spake the saying openly. And Peter took him, and began to rebuke him. But he . . . rebuked Peter, and saith, Get thee behind me, Satan: for thou mindest not the things of God, but the things of men.[34]

What a change of language is here! The popular preacher and healer has gone. One might put it thus. He never returned from Tyre! The man who returned from Tyre was no popular Messiah who was to succeed in winning Israel to God. He was the man who would be put to death. The word "charged" that I have italicized above is the same word used in Mark 1:25. It was a word by which he cast out devils. It means "rebuked." He *rebuked* them. He must kill this idea of the popular Messiah who would be followed, and prepare their minds, as he had attuned his own in what I have called the second desert experience, to the idea of death. His violence to Peter is not so shocking as it sounds to us. Professor J. A. Findlay, to whom I am indebted in this section, told me that he once heard a cab driver in Jerusalem call another "Shaitain," and that he thought Jesus meant no more than the word "stumblingblock" as in Matthew 16:23: "Thou art a stumblingblock unto me!" But I think I can understand the violence of

[34] Mark 8:27-33.

Jesus. If you have only just become accustomed to a new idea and are hanging on to it precariously and at great cost to your natural desires and feelings, if you have fought a temptation and just won, it is indeed terrible if a friend tries to win you back to the earlier idea, surrendered at such cost. The measure of Jesus' violence with Peter was, surely, the measure of the strength of the temptations of the second desert experience, among the lonely sand dunes of the Tyrian coast.

The narrative passes almost immediately to the story of the Transfiguration; [35] and when we turn, in the next chapter, to the study of some of the particular words Jesus used about his death, I shall try to show how immensely significant are those in which Jesus explained that strange experience to his men.

In the meantime it is enough to show that, after his experience at Tyre, there was a marked change in the mental point of view of Jesus and thus in his words. He began to speak openly of his death.

3. *All this involved a change in the demeanor of Jesus.* We read sentences like this, "He steadfastly set his face to go to Jerusalem." [36] Later still we read, "Neither durst any man from that day forth ask him any more questions." [37] When for the second time he had spoken of his death, we read, "They understood not the saying, and were afraid to ask him." [38] Luke says, "They understood not this saying, and it was concealed from them, that they should not per-

[35] Mark 9:2-8; cf. Luke 9:28-36.
[36] Luke 9:51.
[37] Matt. 22:46.
[38] Mark 9:32.

ceive it: and they were afraid to ask him about this saying." [39]

The parable of the wicked husbandmen, which, be it noted, comes as late as chapter twelve in Mark's narrative, summarizes, perhaps, our Lord's own thought. What sadness is in the words, "They will reverence my son"! In that story the son believed at first that he would not be rejected. But the parable ends with the beloved son dead and the doom of destruction menacing his murderers.

So, as we read the Gospels, we watch Jesus going on alone in a loneliness of spirit that even his closest friends could not understand. But in the light we have now we can say this. Something that was plotted by wicked men contained within its horror an interim or circumstantial will of God. It had not been the ideal intention of God that Jesus should die. But in the evil circumstances which men created through misuse of their free will, his death was, in those circumstances, God's will. Many of his people know at least this kind of situation. For example, God's ideal intention for every woman is marriage and motherhood; but if an evil like war makes that impossible, a good woman will not let evil circumstances defeat her. She perceives God's interim will. She grasps the circumstances and takes such a creative attitude to them that she *makes* them, in cooperation with God, work out to as glorious an end as marriage could achieve. Jesus did not go up to Jerusalem to get himself put to death. There was no suicide spirit about it. By the hands of wicked men he was crucified and slain, as Peter said afterward. [40] But Jesus did not allow evil

[39] Luke 9:45.
[40] Acts 2:23.

circumstances to defeat him. By his faith and his positive creative attitude, won at bitter cost in Gethsemane, he swept evil into the stream of divine purposefulness. He knew that if only he was brave and confident and kept close to God, then, not only in spite of, but *through* the evil plots of evil men, his Father could accomplish as great a redemption as he could have accomplished if the beloved Son had been followed and not rejected. We hush our minds and almost hold our breath as we watch him going up to Jerusalem to challenge evil in its stronghold to do its worst, asserting his mastery over it, and so wresting it and grappling with it and reacting to it that he forces it out of the channel of unusable evil into the channel of the purposes of God. If not by his words, then by his deed he will win men. If not by the way of success, then by the way of so-called failure. If he cannot make them see by living, he will by dying. But no man shall take his life from him. He will lay it down of himself.[41] ("The bread which I will *give* is my flesh, for the life of the world." [42]) All things are delivered unto *his* hands; [43] and in God's name he will claim all circumstances that evil machinations can devise and remain master of them, through death's dark valley, out to that vindication on the other side which, in the lonely months at Tyre, has been revealed to him as his Father's alternative plan.

When Jesus came back from Tyre, he was not the popular Messiah of Israel only. He was, and knew himself to be, the Saviour of the world. The hush of a great awe falls

[41] John 10:18.
[42] John 6:51.
[43] John 13:3.

54

upon us. For though he was very God of very God, he was also the most human and lovable Man the world has ever known. But now he is no longer the idol of an adoring populace, the young man with sunny face and laughing eyes, playing with children, reveling in birds and flowers.

> How does that visage languish
> Which once was bright as morn!

He moves on into a mental country into which we cannot enter even in imagination, into a loneliness which would have proved intolerable but for his Father. Is it imaginative to feel that there is a lump in his throat as he cries, "He that sent me is with me; he hath not left me alone; for I do always the things that are pleasing to him"? [44] So this Son of God, this Son of man, this Son of the open air and sunshine, moves into the deepening shadows, carrying his heavy burden, despised and rejected, misunderstood and scorned, lonely and sorrowful save for that ineffable mystery of the divine communion—"I am not alone, because the Father is with me." [45]

[44] John 8:29.
[45] John 16:32.

CHAPTER III

What Jesus Said About His Cross

IT WOULD seem reasonable, in trying to understand the meaning of the Cross, to study the words which Jesus himself used about it when he realized that his death, so far from being the end and failure of a ministry, was itself a baptism into a wider one, the costliness and scope of which are beyond our apprehension and could be disclosed only gradually even to him.

If we took all the sayings in the Gospels in which Jesus referred to his suffering or death and tried to penetrate their meaning, we should need a whole book for the purpose and a greater scholarship than I possess. This has been done by my friend Dr. Vincent Taylor, principal of Headingley College, Leeds, in his book *Jesus and His Sacrifice*. With his permission I have printed in an Appendix to this volume a list of the sayings in the order in which he gives them. There are about fifty.

From these I have chosen some half dozen which seem to me the most significant,[1] and I want at this stage to state the conclusion to which I think they all point, so that, as we discuss them, the reader may have the conclusion in mind and ask himself whether or not they support it.

[1] One important saying is omitted because its discussion is more relevant at a later stage. See pp. 118ff.

That conclusion is of immense importance, and I therefore print it distinctly, asking the reader, even at some inconvenience, to turn back to it again and again, and keep it constantly before his mind:

THE WORDS OF JESUS ABOUT HIS SUFFERING AND DEATH REVEAL THAT HE WILLINGLY COMMITTED HIMSELF TO SOME MIGHTY TASK, COSTLY TO HIM BEYOND OUR IMAGINING, BUT EFFECTING FOR ALL MEN A DELIVERANCE BEYOND THEIR OWN POWER TO ACHIEVE, AND THAT IN DOING SO HE KNEW HIMSELF TO BE UTTERLY AND COMPLETELY ONE WITH GOD THE FATHER.

What the task and the cost and the deliverance were we shall ask in subsequent chapters and do our best to answer. But let us examine the sayings and see if they take us to that position.

1. Chronologically the first was the one quoted already, which immediately followed Peter's confession, after our Lord returned from Tyre: "The Son of man must suffer many things, and be rejected by the elders, and the chief priests, and the scribes, and be killed, and after three days rise again." [2]

About this saying I only want to make two comments. The less important is that the phrase "after three days" implies no more definiteness than our phrase "after a time," or "in a little while," or even the one word "subsequently." As we know, Jesus rose from the dead after little more than thirty-six hours from the time of his death.

My second comment is to focus the reader's mind on the word "*must*." It occurs more than once in the sayings of

[2] Mark 8:31; cf. Matt. 16:21, Luke 9:22. See above, p. 51.

Jesus about his death,[3] and in our minds it links up with other passages. Here is one: "Other sheep I have, which are not of this fold: them also I *must* bring, and they shall hear my voice; and they shall become one flock, one shepherd." [4] Here is another: "The gospel *must* first be preached unto all the nations." [5] Here is another: "They knew not the scripture, that he *must* rise again from the dead." [6] And here is yet another most significant word which Jesus himself spoke after the Resurrection: "*Ought* not Christ to have suffered these things," or, "*Behoved* it not the Christ to suffer these things," or, as Moffat puts it, "*Had* not the Christ to suffer thus?" [7]

Whence this sense of "must" and "ought"? Was he the *victim* of the circumstances of evil? Was it the compulsion of Herod? Was it the "ought" of Caiaphas? Was it the plotting of evil men that drove him thus to speak? Is the passion story the story of one who merely came too near the wheel of events and was caught and crushed? Is this just another story of martyrdom in a great cause, leaving behind a tender memory and the appeal that all heroic sacrifice makes to our hearts?

My answer is a most emphatic No! The stage was set by evil hands; the circumstances were produced by evil men; but the hero was not their victim but their Master, and the passion play carries his meaning, not theirs. The "must" and "ought" came, not from Herod or Caiaphas or the Pharisees, let alone from Judas, but from God himself, to

[3] Mark 8:31; Luke 17:25; 24:7.
[4] John 10:16.
[5] Mark 13:10.
[6] John 20:9.
[7] Luke 24:26.

whose perceived will the heart of Christ said, without faltering, Yea, and Amen.

How can the compulsion be viewed otherwise? *"Ought not Christ to have suffered these things?"* It was Christ's own question. But the word "ought" is an outrage if the compulsion be thought human. *Ought* a man who has done nothing but good to be nailed up on a cross and left in the sun to die? *"Behoved* it not the Christ to suffer these things?"* In other words, "Wasn't it fitting?"

You listen here almost breathlessly, for you expect those to whom the question was put to burst out with, "No, of course, it wasn't *fitting!" Fitting* that the loveliest life that ever lived should be murdered by jealous, cruel priests? Supposing you had adored someone, left all and followed him, watched him healing, heard him preaching, seen in him a new glory that transfigured life, believed that he would bring in a new age, and then he had been struck down and brutally murdered by an insane gang of jealous, plotting priests, and someone had come up on the road who seemed to be the only one in Jerusalem who hadn't heard all about it and had said to you, "But wasn't it quite fitting?" Fitting!

But they do not thus protest. And one of the psychological miracles in the New Testament is that none of the apostles protested. From the very beginning it seems that they never regarded his death as a vile murder. It *was* that, but it carried a divine meaning and significance. God had taken charge of the play and was working it out to an end of his own, and to that divine touch on evil events Jesus in utter dedication consented. "Not as I will, but as thou wilt." [8]

[8] Matt. 26:39.

Here is the seed of thought that grew to a mighty tree in the early church and bore fruit in Paul's phrase, "Far be it from me to glory, save in the cross of our Lord Jesus Christ." [9] No New Testament writer called it a damnable crime or even a grievous miscarriage of justice. They "*gloried*" in the equivalent of something worse than the hangman's rope. They hardly glanced at it from man's angle. It was used to carry through a divine purpose.

2. Turn to another significant saying which occurs immediately afterward. Jesus is coming down the mountainside after the Transfiguration. He has had an experience with Moses and Elijah which is beyond our fathoming.[10] It must have been Jesus himself who told his men what his conversation with these two leaders had been about. We have this only in Luke's account, but his words seem to me of the very utmost importance. Here they are: "There talked with him two men, which were Moses and Elijah; who appeared in glory, and *spake of his* DECEASE *which he was about to* ACCOMPLISH *at Jerusalem*." [11] What strange words! The margin of the Revised Version gives "departure" instead of "decease." Moffatt translates thus: "Moses and Elijah, . . . telling how he *must* go through with his death and departure at Jerusalem!" The word for "decease" in Greek is "exodus." The word used for "accomplish" in Greek is "fulfill." What a strange way to speak if this is a death in the same category as a martyrdom. Nurse Cavell, Captain Oates, Father Damien, David Livingstone—these names of people who laid down their lives for a cause or

[9] Gal. 6:14.
[10] I have tried to interpret it in *His Life and Ours*, pp. 179 ff.
[11] Luke 9:30-31.

an ideal occur to the mind. It would seem more than a little strange to write of the "departure" they "*achieved*," the "exodus" they "*accomplished*." But the word "exodus," used immediately after the allusion to Moses, surely was *meant* to indicate that, as Moses led those under the tyranny of Egypt through a great deliverance to a Promised Land by means of what we call the Exodus, so Jesus would lead those under a greater tyranny through a greater deliverance to a greater glory by his "exodus" or decease.

Moreover, as we contemplate this matter in the light of subsequent events, we see a still greater significance in the fact that Jesus appeared to fail. He was crucified by his enemies. Moses also appeared to fail and died on Mount Nebo, in sight, but only in sight, of the Promised Land; and while he got Israel out of Egypt, he never, as someone has said, got Egypt out of Israel. With a glorious sense of timelessness the author of the Epistle to the Hebrews says that Moses bore "the reproach of Christ." [12] Elijah also, trying to save his people from Ahab's attempt to enforce the worship of many gods instead of the one true God, felt an abject failure. "He requested for himself that he might die; and said, It is enough; now, O Lord, take away my life; for I am not better than my fathers." [13] But in fact Elijah saved the "godly remnant" of Israel which alone preserved that pure stratum of religion in the world and which formed the only possible soil in which Christianity could have taken root. In one sense Moses and Elijah and our Lord were all saviors of the world. If any one of them had failed, it is hard to see how Christianity could have

[12] Heb. 11:26.
[13] I Kings 19:4.

come to be, and yet all three had a sense of failure that felt like despair.

The mention of these two great deliverers in connection with the death of Jesus surely points to our prestated conclusion that Jesus had already, in mind, committed himself to a mighty task, costly to him beyond our imagining, but effecting for all men a deliverance beyond their own power.

3. Turn to the word "cup," as Jesus used it. None of his hearers would fail to know that "to drink the cup" meant to accept a divinely appointed lot. We remember how James and John asked for the highest places in the kingdom. Jesus replies, "Are ye able to drink the cup that I drink?" [14] In the Garden of Gethsemane he prays, "O my Father, if it be possible, let *this cup* pass away from me." [15] And yet again he says, "O my Father, if *this* [*cup*] cannot pass away, except I drink it, thy will be done." [16]

But most poignant of all is the sentence in the Fourth Gospel: "The cup *which the Father hath given me*, shall I not drink it?" [17]

Let those sentences about the cup, especially *"the cup which the Father hath given me,"* become cumulative in their effect upon the reader's mind, and immediately the dying of Jesus is taken right out of the category of martyrdoms. If it were a martyrdom, then John and James *could* have drunk the same cup. Tradition says they did. If the death of Christ were only the result of the successful plotting of the priests to get a troublesome teacher out of the way, why should Jesus speak of "the cup which *the Father*

[14] Mark 10:38; cf. Matt. 20:22.
[15] Matt. 26:39; cf. Mark 14:36.
[16] Matt. 26:42.
[17] John 18:11.

hath given me"? He might more accurately say "the cup which Caiaphas hath given me." Does not the answer point once more to our prestated conclusion?

Another question has often been reverently asked. Why did Jesus shrink as he did from drinking this cup to the bitter dregs? The sufferings of crucifixion, so far from being dismissed lightly, only fill the imaginative mind with horror and the sensitive body with feelings of sickness. I found the realistic Passion Play at Oberammergau in 1934 almost intolerable. Scores of people fainted in the auditorium; and my host, Alois Lang, who played the part of Christ, fainted on the cross. I have described the physical suffering of Christ in another book [18] and shall not dwell on it in this.

But the question in thoughtful minds recurs, though many feel it is almost irreverent to ask it. It is this: Terrible as his sufferings were, others have suffered more in terms of physical pain; why, then, did he say the things he said? "He . . . began to be sorrowful and sore troubled." [19] "He . . . began to be greatly amazed, and sore troubled." [20] "He kneeled down and prayed, saying, Father, if thou be willing, remove this cup from me. . . . And being in an agony he prayed more earnestly: and his sweat became as it were great drops of blood falling down upon the ground." [21]

Yet the lovers of Jesus were thrown to lions, boiled alive in burning oil, crucified by the hundred, persecuted with all the devices the Roman authority could imagine to entertain the crowds around the arena, and later with all the

[18] *Personalities of the Passion*, pp. 99-100, 131-36.
[19] Matt. 26:37.
[20] Mark 14:33.
[21] Luke 22:41-44.

horrors of the Inquisition; and, what is more, they endured these tortures singing songs of triumph and joy. Brave men faced a terrible death for Christ's sake, and not a word escaped their lips. Tender girls were stripped naked and bound between the horns of wild oxen to make a Roman holiday in a heathen arena because they would not give up faith in Christ and would not worship the emperor. And they bore it without a whimper.

Who can suppose that the one who called forth such faith could not suffer his own death, however terrible, with equal fortitude? Only recently a doctor friend of mine was telling me of a man trapped in a bombed house, with unspeakable injuries done to the lower part of his body and a burning beam across his face. The fire was extinguished, but the presence of the man was unsuspected. He lay in agony for more than three days before he was rescued. He was blinded in both eyes, and his nose was crushed in. He was found, just alive, by men who were clearing away the debris. The doctor said to me—it was during Lent—"It's not much good preaching about the sufferings of Christ after that, Padre!"

But I do go on preaching about the sufferings of Christ because I believe they have a far more profound significance than any sufferings any other human being has ever endured, not because of the measure of their physical torment and agony, but because of who Christ was and is, and because they marked his initiation into something often unsuspected, but something which is the very heart of the gospel. This initiation is suggested by the way in which he speaks of the Cross in terms of a baptism: "Are ye able . . . to be baptized with the baptism that I am baptized

with?" [22] and, "I have a baptism to be baptized with; and how am I straitened till it be accomplished!" [23] We have a similar thought in the idea of a covenant in the words, "This is my blood of the covenant, which is shed for many." [24] These are not words about the physical sufferings of a man. "Baptism," "covenant," used as Christ uses them, are words about an initiation into a mighty ministry on the part of a Divine Being. I cannot accept the thought that the Master showed less fortitude than many of his humble followers. I am therefore once more pressed to our prestated conclusion that Jesus committed himself to some mighty task, *costly to him beyond our imagining*. What that was we will try to indicate later.

4. The same conclusion is reached when we think of another word: "The Son of man came not to be ministered unto, but to minister, *and to give his life a* RANSOM *for many*." [25] Paul uses the same word in his letter to Timothy, "Christ Jesus, who gave himself a RANSOM for all." [26]

I am aware that some commentators reject this passage as unauthentic—Rashdall, for example, in *The Idea of Atonement in Christian Theology*. Yet Vincent Taylor, A. E. J. Rawlinson, Theodore Robinson, and others accept it. I am not competent to judge between them. All I would say on that point is that the saying is in harmony with our Lord's thought in the other sayings about his death. [27]

I am also aware that fantastic theories have been built

[22] Mark 10:38.
[23] Luke 12:50.
[24] Mark 14:24; cf. Matt. 26:28; Luke 22:20.
[25] Mark 10:45; cf. Matt. 20:28.
[26] I Tim. 2:6.
[27] See Appendix I.

upon it, such as, for instance, that the passion and death of Jesus formed the ransom price of our deliverance which God paid to the Devil to bribe the latter to let us off hell. It is strange now to think that that peculiar theory held the thinking of Christendom in thrall for nine centuries.

The saying about "a ransom for many" falls into two parts. The word "ransom" was used to denote, in the Greek world of the first century, the amount of money necessary to purchase the freedom of a slave and make him also *the property or the protégé of some particular god.*[28] What a wealth of suggestive meaning lies behind Mark's use of such a word! [29]

The words "for many" inevitably remind the Biblical student of the use of the same phrase in Isaiah 53:12: "He bare the sin of many." The way in which Jesus thought of himself as the suffering servant there described makes one feel that there is more than reminiscence here and that the ransom passage is authentic. Further, Taylor thinks that we should translate *"instead of many"* rather than *"on behalf of"*: "The Son of man came to give his life as the purchase price instead of the many." He comments:

Undoubtedly, it contains a substitutionary idea, since something is done for the many which they cannot do for themselves. . . . The saying means that, by the willing surrender of his life, Jesus, as the Son of man, comes to provide a means of deliverance for men. . . . The theologian has every reason to

[28] Deissmann, quoted by Vincent Taylor, *Jesus and His Sacrifice*, p. 103.

[29] Dr. C. Ryder Smith says the word is also used to denote "redeem" in the sense of "do a kinsman's part." (*The Bible Doctrine of Salvation*, p. 188.) See below, pp. 90-91.

take the saying into serious consideration in his attempt to discover the secret of the Cross.[30]

This interpretation brings us again to our prestated conclusion printed in capitals at the beginning of the chapter. Further, the reference to the "many" leads to a consideration that ought to come into our survey of the words Jesus used which help us to understand his sufferings and death.

Albert Schweitzer has an important word for us here. Arguing for the significance of the word "many" as meaning that Jesus, linking the thought of his sufferings with those of the suffering servant described in Isaiah 53, was already looking beyond the circle of his own men, and beyond the community of "believers," Schweitzer says:

In the interpretation of Jesus' saying the first requisite is to do justice to the expression "for many." Because they have not done this, all expositions of the significance of Jesus' death—from Paul to Ritschl—are unhistorical. One has but to substitute, for the community of believers with which they deal, the indeterminate and unqualified "many" of the historical saying, and their interpretations become simply meaningless. That interpretation alone is historical which renders it intelligible why, according to Jesus, the atonement accomplished by his death is to redound to the benefit of a number which is intentionally left indeterminate."[31]

Dr. Maltby lays great weight on the evidence that the horizon of Jesus extended as he saw himself to be not merely the Messiah of the Jews but the Saviour of the world. I am not quite so convinced as he is that in this regard the change is so marked. Did not Jesus believe—even

[30] *Op. cit.,* pp. 104-5.
[31] *The Mystery of the Kingdom of God,* pp. 72-73.

in very early days—that if he was accepted, then, through the leaven of a changed Israel, the lump of the whole world would be leavened? Was not the third temptation one by which, through a short cut—one which would have sought to force God's hand and which was therefore rejected—he was to have "all the kingdoms of the world, and the glory of them"? [32] I may be wrong, but I should not have thought that the chronology of the Synoptists was so accurate, or the addition of later amendments—as the church grew and the designs of God became more obvious—was so impossible, as to allow us to conclude that all references to Christ's world mission fall in the period of his ministry subsequent to the disclosure at Tyre of the scope of his redemptive purpose.

Yet I, too, mark the indubitable, world-wide relevance of the gospel as Jesus disclosed it. "My house shall be called a house of prayer *for all the nations*." [33] "What this woman has done shall be told *in the whole world*, as a memorial of her." [34] Even if some scholars deny the authenticity of the exact words, "Go ye into *all the world*, and preach the gospel to the whole creation," [35] yet they are in harmony with Jesus' message, and when we carry them out we know that we fulfill his purposes and do his will.

5. So when we come to the story of the Last Supper, our prestated conclusion seems once more supported. "Jesus took bread, and blessed, and brake it; and he gave to the disciples, and said, Take, eat; this is my body. And he took a cup, and gave thanks, and gave to them, saying, Drink

[32] Matt. 4:8; cf. Luke 4:5.
[33] Mark 11:17.
[34] Mark 14:9 (a paraphrase).
[35] Mark 16:15.

ye all of it; for this is my blood of the covenant, which is shed for *many* for the remission of sins." [36]

I shall not attempt here any adequate exposition of these mighty words, but only make four comments on them:

a) There can be no reasonable doubt that they refer, and that Jesus meant them to refer, to his imminent death. The reference to the Last Supper in First Corinthians [37] is earlier than that in any of the Gospels—it is, in fact, the earliest statement of the New Testament institution of the Supper—and it adds the clause, "For as often as ye eat this bread, and drink the cup, ye proclaim *the Lord's death* till he come."

b) The two earlier Gospels have "for many"; Luke and Paul have "for you." Schweitzer argues that we should take the two earlier as the more accurate and that an attempt was made by Paul to restrict the meaning and value of the death to the few.[38]

c) The words used, "This is my body," cannot be the basis of any interpretation that makes Jesus and the bread identical, for when they were first spoken Jesus was reclining at table with his men. "This means my body; this means my blood," would be an accurate translation of the words, and Dr. Moffatt translates them in his way.[39] "My body is to be broken and my blood poured out for the sake of the many"—that seems to me a fair interpretation of the

[36] Matt. 26:26-28; cf. Mark 14:22-24.

[37] I Cor. 11:23-26.

[38] Cf. Mark 14:24; Matt. 26:28 with Luke 22:19-20. "Paul wrote from the standpoint of the Church after the death of Jesus. From this point of view the saving efficacy of Jesus' death is applied to a determinate community, to those, namely, who believe on him." (Schweitzer, *op. cit*., p. 71.)

[39] See Moffatt's translation and Vincent Taylor, *op. cit.* p. 123.

sacred words. Dibelius writes: "A Jewish Christian Church with its dread of blood would scarcely have made Jesus say 'this is my blood' (in the cup), but rather 'this cup means a new covenant which is instituted by my blood, i.e. by my death.' " But, as Taylor says, "Jesus does not invite his disciples to drink blood, or to drink blood symbolically, but to drink wine as representing his life surrendered for many. . . . There is no probability that Jesus saw any objective virtues in blood, or implied that his word transformed the 'substance' of wine into the 'substance' of blood." [40]

d) No Jew present could possibly miss the association of ideas when Jesus used the words "covenant" and "blood" in the way reported in the Gospels. Every Jew kept the Feast of the Passover and knew by heart the story of how the Angel of Death passed over those houses whose lintels were sprinkled with blood. That also was a mighty deliverance effected through blood and beyond man's power to achieve.[41] It is as though Jesus said, "The pouring out of my blood means another covenant with God, effecting this time not a physical but a spiritual deliverance." The idea of drinking Christ's blood was not intended. It was a pagan idea revolting to the Jew. It was familiar to the pagan world, where the god was consumed that his nature might be reproduced in the worshiper, just as men believed that by eating the flesh of the hare men became swift, or that by

[40] Dibelius, *From Tradition to Gospel*, p. 207; quoted by Taylor, *op. cit.*, pp. 134 ff., where the reader will find a brilliant discussion of the words instituting the Last Supper, taking full note of "the fact that the Jew regarded the drinking of blood with horror"—as J. Klausner, a Jew, writes, "The drinking of blood, even if it were meant symbolically, could only have aroused horror in the minds of such simple Galilean Jews." (*Jesus of Nazareth*, p. 329.)

[41] Exod. 12:1-14.

eating the flesh of the lion men became strong. There is no reason to suppose that, at the institution of the Supper, Jesus supported this superstition.

We come back, then, from a discussion of the most significant words which Jesus used about his sufferings and death to find, I think, that they all support the statement made at the beginning of the chapter, which I purposely left with terms in it which we will try subsequently to amplify. Let me state it again:

THE WORDS OF JESUS ABOUT HIS SUFFERING AND DEATH REVEAL THAT HE WILLINGLY COMMITTED HIMSELF TO SOME MIGHTY TASK, COSTLY TO HIM BEYOND OUR IMAGINING, BUT EFFECTING FOR ALL MEN A DELIVERANCE BEYOND THEIR OWN POWER TO ACHIEVE, AND THAT IN DOING SO HE KNEW HIMSELF TO BE UTTERLY AND COMPLETELY ONE WITH GOD THE FATHER.

Now we can go on to discuss the task, the cost, and the deliverance.

CHAPTER IV

The Task to Which Jesus Committed Himself

WE HAVE seen in Chapter II that the death of Christ cannot adequately be described in terms of the plotting of a handful of scribes and Pharisees against one who challenged their whole system of religion and exposed it for the mockery it was.

We have seen in Chapter III that our Lord's own words confirm the conclusion that he took hold of the historic situation which their evil had set up, that he used the stage setting of that evil to work out a plot which was his Father's secondary plan. He made the Cross carry his meaning, not theirs, and fulfill his purpose, not theirs.

Since he had failed to win acceptance—his Father's primary plan—he would use the very means of his rejection to bring about that same end which acceptance would have secured.

God did not compel him thus to act. He was not made to play a role to which he was unavoidably assigned. Of his own choice, in utter harmony with God, he *chose*, for our sake, this lonely and dread task.

Let us ask in this chapter what this mighty task was to which he committed himself. We will ask later how and

why his dying contributed to this end, what his dying achieved, and at what cost. If we can take a look at the goal aimed at, we shall be a bit further on in the task of answering these other questions.

I think we may set down the answer quite simply, though its implications will involve perhaps an eternity of meditation.

The "mighty task" was to effect the reconciliation of all mankind with God. Paul puts it in one pregnant sentence: "God was in Christ reconciling the world unto himself." [1]

As we have seen, when the ministry of Jesus opened in Galilee, his thought was primarily for Israel. This remained his dominating purpose up to, and even during the early days of, his sojourn at Tyre. It is illuminating to recall words actually used by Jesus while he was at Tyre. "I was not sent but unto the lost sheep of the house of Israel." [2] Then, as we have also seen, his horizon extended. We read of the "many," and then of "the world."

In the Fourth Gospel are recorded words which express his world purpose: "God so loved *the world*, that he gave his only begotten Son, that *whosoever* believeth on him should not perish but have eternal life." [3] Words like these could be multiplied. Perhaps the most striking are these: "He [Caiaphas] prophesied that Jesus should die for the nation; and not for the nation only, but that he might also gather together into one the children of God that are scattered abroad." [4] It is hard to suppose that those words were spoken exactly in that form by Caiaphas. I think we may

[1] II Cor. 5:19.
[2] Matt. 15:24.
[3] John 3:16.
[4] John:11:51.

suppose that John often edited and added to actual sayings. For instance, even in the famous text, "God so loved the world . . . ," no one knows whether to attribute them to Jesus or to the evangelist. Authorship apart, however, we must muse for a moment on words which mean that the mighty task to which Jesus committed himself was nothing less than that of bringing all mankind, past, present, and future, into harmony with the loving purposes and holy will of God.

If it is asked how anyone, by an act done in history, can affect those who lived before him, I can only guess at answers. It used to be said that in the interval between the Cross and the Resurrection, Jesus, to use a phrase in one of Peter's epistles, "went and preached unto the spirits in prison" [5] meaning those who lived in the pre-Christian era. It is popularly believed that the phrase in the creed, "he descended into hell," does not mean the supposed hell of pain, but, as a footnote in all prayer books is careful to point out, "the world of spirits." Obviously at the Transfiguration Jesus had a great deal to do with those who lived before him. He conversed with Moses and Elijah, his great forerunners. We read also of an occasion when he was challenged by his enemies:

Jesus answered, . . . If a man keep my word, he shall never see death. The Jews said unto him, Now we know that thou hast a devil. Abraham is dead, and the prophets; and thou sayest, If a man keep my word, he shall never taste of death. Art thou greater than our father Abraham, which is dead? and the prophets are dead: whom makest thou thyself? Jesus answered, . . . Your father Abraham rejoiced to see my day;

[5] I Pet. 3:19.

and he saw it, and was glad. The Jews therefore said unto him, Thou art not yet fifty years old, and hast thou seen Abraham? Jesus said unto them, Verily, verily, I say unto you, Before Abraham was, I am.

No wonder we read on thus: "They took up stones therefore to cast at him: but Jesus hid himself, and went out of the temple." [6]

We must not shrink, then, from the view that Jesus in his ministry of redemption did not overlook those who died before him, or died after him without ever hearing about him. The accident of time, beyond whose power the dead have passed, would indeed be a terrible thing if it could block from all the "benefits of his passion," those who lived before he lived on earth, or who died before having any real chance of accepting him. A friend of mine tells of a sermon he read which was preached by Robert Moffatt, father-in-law of David Livingstone. He found it hard to read, not only because of "its length—it must have taken over an hour to preach—but because of its viewpoint. The preacher believed that the missionary must hasten because of the millions of heathen folks who were falling into hell every second that passed. . . . An intolerable view of God was implied—that souls were sent by him to eternal horrors for not believing what they had never heard. If only they could hear and accept the love of Christ in time, then apparently they would be safe." We see that there must be a redemptive activity of Christ outside the particular prison we call time.

I cannot pretend to see the matter without shadows. We

[6] John 8:51-59. Note how tired and worn our Lord probably looked. "Thou art not yet fifty years old." He was only about thirty.

75

all speak from within the prison of time and space, and cannot escape it however we try. But humanity is an entity not completely conditioned by space and time. Moreover, it is a unity only accidentally divided by both. Jung, the famous psychologist, speaks of the "collective unconscious." Go down far enough, and you and I, while preserving our individuality, are one, as are the continents. Africa is Africa, and Europe is Europe, and the wide seas divide them. But go down far enough and all are one, "parts of a single continent," and anything that altered them from below would alter them throughout. If one could imagine the nature and chemical constitution of the earth altered from the earth's center, then the Himalayas and the Pennines, the Apennines and the Andes would register the difference, though wide seas divide them.

Illustrations are not arguments, but I can imagine that as the seas divide the continents, so time divides the generations; but below the dividing seas, past men, present men, and future men, preserving individuality, are yet one; and a Timeless Divine Being entering humanity with the power of a God could influence the whole of humanity, past, present, and future. But more of this later.

Here I think I must make another point clear. If Jesus of Nazareth was only a man, then, of course, what I have been saying, and most of what I want to say, is absurd. Those who still think of him as a good man will have to explain his Cross as best they can in terms of martyrdom, sacrifice for a good cause, a passionate adherence to the highest human values, and so on, though what they will make of the evidence about the Cross I don't know.

I am completely unable to understand Jesus Christ on

that lowly level of interpretation. I believe in his real humanity. I glory in it. He is what God meant human nature to be like. But though there is not space to argue it here—and indeed I have attempted it elsewhere [7]—I do most earnestly believe that Jesus Christ had all the values of God which a human life can express. God *became* man. (How hard it is to receive the truth of three simple words!) Not that Jesus was a godly or godlike man. Not even that Jesus took the form of man, in the sense of assuming the disguise of humanity for a brief sojourn on this sinful earth—much as a student friend of mine took the form of a tramp and slept in public houses and under haystacks to feel what it was like to be a tramp, being very ready at an early stage in the experiment to wire his father for money and resume the privileges and powers he had temporarily given up!

No, in a way which we shall see more clearly when we come to Chapter VI, on the cost of our deliverance, I believe that in Jesus Christ God became man; and when a Timeless Being enters humanity, which—in the timeless or real world—is an entity undivided by space and time, then no one is excluded from that marvelous and blessed invasion because of the accident of the date of his birth.

That being stated, let me write down again what the mighty task was. It was, and is, to gather all men into God's family in harmony with one another and with himself—to reconcile *the world* unto himself.

It will not be a waste of time to let the mind dwell on this holy purpose, to forget for the moment the division and strife between men. Within a family, even where love

[7] *His Life and Ours*, chap. i.

dwells, there is sometimes misunderstanding and quarreling. Between communities there is suspicion and dislike. Between religious sects claiming to follow Christ there is antipathy and contempt. Between countries there is a motive of power politics that hinders trust and friendliness. War ravages the world. We do not need to dwell on that.

But we all know families where everybody loves everybody. They don't all believe the same thing or do the same thing. They are not all at the same level of development. There are little brothers and sisters who have further to go in self-development than older and wiser boys and girls. But the family is a loving unity. The joys of one are the joys of all. The privileges of one are shared by all, even if only in terms of delight. The pain of one is the concern of all. The deprivations of one are felt by all. The sins of one are the shame of all.

What Jesus has done is leave the shining seats above, the unlimited godhood, the glory that he had with his Father before the world was, and come into this human family at a place in space and a time in history which we note as Bethlehem in 4 B.C.; [8] and, finding himself rejected, do something by his passion, death, and resurrection, a something yet to be studied, which will result—which has already resulted perhaps among those whom we label B.C. and call "the dead"—in making the whole of humanity the kind of family I have described.

Whether it will be done on this little wayside planet we call the earth I cannot say. Some say Yes. They speak of the consummation of the age, of the second coming

[8] A mistake in the calendar accounts for this seemingly absurd statement.

of Christ. Paul belonged to this school and in his earlier writings laid much emphasis on this teaching. Others think that this earth is only the first-grade room of a school for very little boys and girls, and that we must go through all the grades, and then to a bigger, better school, and then to the university, before we graduate into that high standard of spiritual education which the redeemed know in heaven. All theological thinkers, however, seem to believe that the story of the adventures of humanity which we call human history will have a worthy climax and not fizzle out as what Mark Twain called "a rather discreditable incident on one of the minor planets."

For our argument in these pages, the consummation is too remote to be relevant. But let us glimpse the mighty task. No single individual can be *coerced* into the family relationship. You must either be born into a family or be adopted into it. You cannot be forced into it, or force your way into it. And no one must be frightened into it by having the horrors which follow rejection burned into a harassed mind. If that had been the way of Jesus, he would not have turned back the legions of angels. See, in imagination, the mighty hosts of the unseen world, loving the divine Son and longing to break through to help him. But no, he had long ago put the method of the short cut behind him when he overcame the temptations in the first desert experience. He knew the legions of angels were there; [9] but he also knew that they must be held back in the leash of loving regard for men, in that divine restraint which, infinitely desiring, will never achieve its end at the cost of men's mental processes and voluntary choices.

[9] Matt. 26:53.

Indeed, the method would defeat the end. For the end is not to win men's allegiance whatever the conditioning of that allegiance, but to win it by man's own free consent. The invasion of supernatural hosts of angels might have cowed men into groveling abasement, but they would not have been worthily won. So men went home on the night of the Crucifixion and ate and drank and laughed and slept, when, if the legions from the unseen had had their way, they might have been swept away as thistles before an avalanche, or have been left gibbering imbeciles, robbed of reason by the impact of supernatural forces which the human mind is not constructed to bear.

We may dream, if we like, of what a redeemed world would be like. It would not mean regimentation any more than a unified family reduces all its members to uniformity of expression. It would not mean, surely, that all would share the same intellectual outlook and belief, or attain the same degree of achievement, any more than it does in a family.

It would mean that the whole earth would comprise a family of nations, that all the resources and provision which God has made would be shared, so that poverty and want and almost all ill health would be done away. It would mean that love to God and loving service to men would become the dynamic motive of all activity. In every quarter of the globe, children born into the world would be given the chance to realize all their possibilities. Physical health, mental fitness, spiritual radiance would be common to a humanity blossoming into forms and patterns of loveliness as various as the flowers of the field. The conditions we spoke of as characteristic of the ideal human family would

pertain in every family in every group in every land. The whole earth would be full of his glory.

If it is not God's plan to achieve this on this earth, then those conditions which are relevant to the next phase will apply there in the redeemed society whatever the environment, whether it be earth or heaven, or, as some say, another planet. Surely God's plan is to bring all his children, with all their possibilities harmoniously realized, into communion with himself with that quality of communion that Christ enjoyed on earth.

Indeed, I do not shrink from dreaming that the mighty task will not be consummated until all men are like Christ. They will not be God, or share the unity of the Godhead, but the New Testament repeatedly uses such phrases as, "We shall be like him." [10] What a strange thing if in Genesis is the story of Adam's attempt to pluck divinity in one proud leap—"Ye shall be as gods" [11]—and if in the last chapter of earth's history book we shall read that this is in fact what happens through the sacrifice of the Second Adam! Thus would come true the famous saying, "The Son of God became the Son of Man in order that the sons of men might become the sons of God." Dr. H. R. Mackintosh says, "It was one of the underlying maxims of Luther that human nature has been created for participation in the life of God and is destined to reach it to a degree of which we can form no conception save from the exemplary instance of Jesus Christ our Head." [12]

It seems an immense undertaking, but nothing less could

[10] I John 3:2.
[11] Gen. 3:5.
[12] *The Person of Jesus Christ*, p. 239.

be described as "redeeming the world," "taking away the sin of the world," "saving the world," "reconciling the world." In his death and passion, in his resurrection and subsequent ministry, I believe our Lord did something which eventually will work out in this way.

When, instead of thus dreaming, we view the present situation, our hearts grow faint, and faith falters. When we see the evil enthroned against him, the selfish, cruel, indifferent, lustful, jealous, proud, cowardly, power-craving hearts of men and women; when we realize the state of our own hearts and know how far we are from our own full redemption; when we realize that winning men to God is usually a one-by-one task, that no one can be won apart from the surrender of his own will and his own free choice of God, and that some men hold out against God all their lives; when we think of millions in the Far East living and dying without a real chance to understand what Christ has done, then we cry, "How long, O Lord, how long?"

But faith returns when we look at him. The timeless, divine Christ could already with truth use the past tense: "Be of good cheer; *I have overcome* the world!" [13] And faith in him is confirmed when we listen to the saints: "We see not yet all things subjected to him. But we behold . . . Jesus, . . . crowned with glory and honor"; "In the name of Jesus every knee should bow, . . . and . . . every tongue should confess that Jesus Christ is Lord, to the glory of God the Father"; "For he *must* reign, till he hath put all his enemies under his feet"; "He shall reign for ever and ever." [14]

[13] John 16:33.
[14] Heb. 2:8-9; Phil. 2:10-11; I Cor. 15:25; Rev. 11:15.

It is hard to make sense of the New Testament without making room for the thought of a mighty task achieved already, at least in the timeless world, and working out its effects in this time-space stage to a mighty climax, to

> . . . one far-off divine event,
> To which the whole creation moves.

And without wresting scripture for our own purposes, it is impossible to avoid the conclusion that this climax and the passion and death and resurrection of Christ are causally related.

I heard a great voice in heaven, saying, Now is come the salvation, and the power, and the kingdom of our God, and the authority of his Christ: for the accuser of our brethren is cast down, which accuseth them before our God day and night. And they overcame him *because of the blood of the Lamb*.[15]

[15] Rev. 12:10-11.

How Men Have Interpreted the Cross

HAVING stated in words, however inadequately, the mighty task to which our Lord committed himself—namely, to win the whole of humanity, past, present, and future, to unity with God—we seek to explain *how* the passion and death of Christ effected the winning of the world to God. To do this we ought to look, in passing, at the roads along which other minds have traveled toward the central truth.

Some of these interpretations will seem crude, just as ours may appear crude to those who approach the subject from a different angle. But though we must not stay on these old theories, let us look at them reverently and remember three things about them.

First, the truth is too great to be tucked neatly into any theory. Though in this book I shall try to suggest an interpertation which carries my own mind further than any other theory, I have no hope whatever of being able so to state in words what the Cross of Christ means that no further mystery surrounds it. We will seek to find in the vast seas of mystery a "wave-washed mound," so that the horizon is, perhaps, lifted a little; but

> From this wave-washed mound
> Unto the furthest flood-brim look with me;
> Then reach on with thy thought till it be drowned.

Miles and miles distant though the last line be,
And though thy soul sail leagues and leagues beyond—
Still, leagues beyond those leagues there is more sea.[1]

The reader must come to every theory with the understanding that no maker of theories can do more than guess. We are all in a sea of immense ignorance and mystery. To compare what we know, or think we know, with what we do not know, is like comparing a speck of sand with all the ocean beaches in the world.

Second, let us look for that element of truth which is certain to be found in those theories which have held the minds of men in thrall, even where the metaphors which express the theories do not happen to appeal to us.

Third, let us remember that a theory is not true because it is new, or false because it is old; neither is it false because it is new, or true because it is old.

I apologize beforehand for devoting only a few sentences to some theories which, in an exhaustive treatise, ought to have at the very least a whole chapter. But I am trying to write for the plain man, and if I turn off my own main road of thought and do more than point up the by-paths that lead away from the conclusion I want to reach, then the plain man is likely to get confused and lost. [2]

Older Theories

I think I can offer the material of this chapter most easily by grouping the best-known theories of the Atone-

[1] Dante Gabriel Rossetti, "The Choice."
[2] The various theories of the Atonement are splendidly set forth in an excellent book by my friend, the Rev. Alex. McCrea, called *The Work of Jesus in Christian Thought.*

ment according to the metaphors which most readily express them.

1. First, then, is the type of theory which centers round the idea of sacrificing an animal. In a mood of penitence the sinner might bring a lamb or goat and have it sacrificed by the priest upon the altar, so identifying himself with the animal offered to God in his stead that he himself believed his guilt transferred and himself set free from the burden of sin. [3] As we have already remarked, it is not surprising that the Jewish mind, to which the ritual of the sin offering was so familiar, saw in the sufferings and death of Christ, the Lamb of God, the crown and consummation of a long sequence of sacrifices. By a self-identification with Christ men believed that atonement was made for their sins and that they were thus made fit for communion with God. [4]

We should not pass this theory by without remembering two things:

a) Enlightened minds in the Old Testament days had already realized the futility of the proceeding viewed only as an act by itself. So Isaiah says: "What unto me is the multitude of your sacrifices? saith the Lord: I have had enough of the burnt offerings of rams, and the fat of fed beasts; and I delight not in the blood of bullocks, or of lambs, or of he goats." [5] The author of the fifty-first psalm, or perhaps an editor who added the final verses, expresses the same idea: "Thou delightest not in sacrifice; else would I give it: thou hast no pleasure in burnt offering. The sac-

[3] Some writers suggest that the fact that the animal was afterwards eaten by the priest had a divine significance. The penitent provided a meal for God. See Vincent Taylor, *Jesus and His Sacrifice*, chap. vi.
[4] See the New Testament references on p. 29.
[5] Isa. 1:11.

rifices of God are a broken spirit: a broken and a contrite heart, O God, thou wilt not despise." [6] The prophet Micah goes further and says: "Wherewith shall I come before the Lord, and bow myself before the high God? shall I come before him with burnt offerings, with calves a year old? Will the Lord be pleased with thousands of rams, or with ten thousands of rivers of oil? shall I give my first born for my transgression, the fruit of my body for the sin of my soul? He hath showed thee, O man, what is good; and what doth the Lord require of thee, but to do justly, and to love kindness, and to walk humbly with thy God?" [7]

b) Another thing to remember, however, is that any ritual *which is believed in* can be effective. We all know how hard it is really to accept the thought and to *feel* that God forgives us, even though intellectually we know it to be true. So if a ritual persuades a man he is forgiven, if he *really* believes that his guilt is transferred to the animal or to Christ, the theory of the Atonement which expresses this thought is cogent for him. Whether intellectually sound or not, it is emotionally satisfying.

Indeed, though we are far from being Eastern Jews and have no traditional background making us familiar with such sacrifices in the temple, the same idea is clung to by modern Christians, as is shown in a hymn like:

> I lay my sins on Jesus,
> The spotless Lamb of God.

What is the matter with this theory? If it satisfies the reader's mind, I will leave it at that. Nothing more need

[6] Ps. 51:16-17.
[7] Mic. 6:6-8.

be said. But the plain man of today does not usually find that this is a place where his mind can rest. The theory contains the grain of truth that reconciliation with God is costly to God. Forgiveness is no mere turning of his back, no mere canceling of a debt. It would be a grave travesty of the situation to hold sin so lightly that we think forgiveness means that God shrugs his shoulders and says to us, "Oh, it is nothing. Think no more about it." The shedding of blood at any rate prevents that error.

But this type of theory fails to help the modern man not only because the idea of the blood offering is foreign to him but because of one simple psychological truth which I hold to be indisputable. It can be stated simply in six words: *Guilt cannot be transferred to another.* I shall write later of the union of Christ with man and will, I hope, show that Christ bears, more poignantly than we can, the *shame* of our sin *because* he was sinless. The nature of sin is such that it blinds us to its own nature. The punishment of sin is essentially the deterioration in character—often unconscious—which follows sin, and which sin sets in motion. Such deterioration involves loss of spiritual perception. As Martineau once said, "Sin is the only thing in the universe concerning which it is true to say that the more one practices it, the less one understands its nature." Sin blinds us to its own horror and shame.

Shame, then, is borne by anyone who loves the sinner, and is innocent, more than it is borne by the sinner himself. But guilt, no! If I have done a wrong thing, then the guilt is mine. I did it. No one else; and not by any juggling with words can this immutable fact be altered. Indeed, I *feel* guilty. I can be forgiven. I can be restored to the relation-

ship of a son. I can be "redeemed" and "saved"; but to pretend that the blame, culpability, or guilt can be transferred to another person is, to me, unreal and untrue. I find it hard to sing with reality the last line in the verse which runs,

> My faith looks back to see
> The burden thou didst bear
> When hanging on the accursed tree,
> And knows her *guilt* was there,

unless one is identifying oneself with all humanity and admitting—what is quite true—that one is the same kind of person as those who crucified Jesus. I regard it as untrue and ultimately immoral to say, "I lay my sins on Jesus," if the word "lay" means the transference of guilt. To be true the words would mean that Jesus felt guilty. I readily recognize how he must feel the shame of our sins; but when words are carefully used, can anyone claim that *guilt* is ever transferred to Christ, that he could be supposed to feel *guilty* if, say, the sinner rapes a child, or robs and then murders an old woman?

2. Second, there is the type of theory that centers round the idea of a contract with the Devil. The theory was held tenaciously for nine centuries. Gregory of Nyassa, Augustine, Iranaeus, and Anselm all express it in various ways. To put it very crudely, it was the view that the passion and death of Christ were the ransom price paid by God to the Devil, so that the latter, who had humanity in his clutches, would let us go and we should escape the pains of hell.

Here again, though the imagery is crude, we must not miss any grain of truth. Jesus used the word "ransom"

himself, and a ransom is paid by someone to someone. Further, this group of theories also contains the truth that our redemption is costly.

Yet the theory seems artificial to the modern man, partly because he is not sure if there is a Devil at all, and partly because, if there is, it seems unreal to imagine his receiving the ransom price in terms of the suffering of someone else. How can a measure of sin be equated with a measure of suffering borne by someone else? If you were willing to "bear" my sins and I stole a shilling, how much suffering would you have to have before the Devil considered the bill had been paid? And how exactly does the *Devil* gain by the transaction? Let it be realized certainly that the nature of the moral universe is such that sin exacts a penalty from the sinner, and that those who give themselves to the task of rescuing the sinner will most certainly be made to suffer in terms of sympathy, shame, and arduous, long endeavor, frequently unrewarded. If the sensitiveness of the helper is sufficient to make him desire to help the sinner, it will certainly be keen enough to make him wounded by the sin. We will return to this thought later.

We need not stay on this group of theories, for they have little to say to the modern man who cannot imagine that a measure of suffering could be regarded as the equivalent of the sins of all humanity, and in some magic way accepted by the Devil as a ransom price paid to him by God. If one advances beyond the magic, even then the dignity of God is lowered, and the word "ransom" used by Christ need not be pressed so literally as to demand that someone be found to receive the price. My friend Dr. C. Ryder Smith argues—as I think, successfully—that our

Lord's use of the word "has no reference to the price considered as paid to the slave owner . . . but only to the price as setting the captive free. . . . When our Lord used the word *lutron* ("ransom"), he thought of himself as kinsman of 'many,' giving his life to set them free." [8]

3. Third, there is a group of theories centering round the metaphor of the law courts. The picture is that of God upon the judgment seat, throned in perfect holiness and righteousness. Humanity is in the dock, a guilty criminal on whom the sentence is about to be pronounced consigning the prisoner to hell. But Christ, the beloved Son, steps up into the dock and agrees to pay the price in his own suffering and death, in order that man may go free.

> Then out of pity Jesus said,
> He'd bear the punishment instead.

Or, as another hymn puts it:

> Bearing shame and scoffing rude,
> In my place condemned he stood;
> Sealed my pardon with his blood.

All the theories of the Atonement known as substitutional are in this category. Jesus, as it were, became our substitute and paid our penalty.

This group of theories also has truth in it, inasmuch as God's holiness and righteousness are such that sin can never be lightly regarded. Man must never, as it were, "get away with" sin, or the universe would be immoral; its fun-

[8] *The Bible Doctrine of Salvation*, p. 189. See also discussion of word "ransom" on p. 66.

damental values would depreciate in worth. This point must be guarded and will be guarded in the pages that follow.

But the plain man of today cannot rest his mind in any view of the death of Christ which depends upon the metaphor of the law courts, for at least three reasons:

a) One is that the Father and the Son are *spiritually separated* thereby. One punishes, the other suffers. It is difficult, as we shall see, to avoid some degree of separation, whatever the theory. My own view involves it. The facts involve it, for Jesus is human and God is not. Jesus is Son and God is Father. But there must not be separation in the *attitude* of the Father and the Son. The thought of the former's punishing the latter when both are one is intolerable. There cannot be *spiritual* separation. God in his holy unity both suffers for and condemns sin. The whole Trinity condemns sin, and the whole Trinity suffers through sin, and a metaphor that separates the persons in the Trinity from both activities stands self-condemned. One may hold, as I do, that God both condemns the sin and suffers in the sinner, but this truth is not very aptly illustrated by the metaphor of the law courts. I cannot now recall who painted a picture which moved me deeply. It represents Christ on the cross, but the cross is upheld by the hands of God, and the whole background of the picture is the face of God with eyes full of suffering, love, strength, and pity. We cannot let go the truth that God was there too. "God was *in Christ* reconciling the world unto himself." [9]

b) The second reason is even more damning to the theory. We must try to use words carefully. How can the

[9] II Cor. 5:19.

Son be *punished* by the Father for doing his Father's will?
The Son throughout his earthly life has offered to God a
perfect obedience, "becoming obedient even unto death,
yea, the death of the cross." [10] The Son has been guided
along a strange, lonely, and terrible road, a road from
which his human nature shrinks, in order that he may ful-
fill the plan of his Father in the evil circumstances which
sin has created. Who can suppose that in consummating
this purpose at his Father's holy demand he can, in that
doing, be regarded as being punished by the Father?

c) The third reason I advance against all the theories
which center in the metaphor of the law courts is in itself
an insuperable difficulty to the plain man. "It is not fair,"
he cries, "to punish the innocent for the guilty." And if
in reply it is said that the innocent was willing to accept the
penalty, then in counterreply the plain man says, "But
how can the word 'penalty' describe what Christ bore,
and how can the measure of the sufferings of Christ be
regarded as the equivalent of a wholly mythical entity
called 'the sins of the world'?" Let us pause a moment and
realize what a mythical entity that is. If you have got
neuralgia, and I have got a headache, and somebody sitting
with us has got sciatica, we cannot really add the pain to-
gether and say that there is that much pain in this room.
In a similar way, one asks what are the sins of the world?
One man is jealous. Another is proud. A third is selfish. A
fourth is angry. But we can't add them together and regard
the sins in a room as mounting up to a higher total as each
new person enters it. So with the sins of a world. And how
can the physical and mental sufferings, even of a divine

[10] Phil. 2:8.

person, be regarded as the equivalent of the total sum of the sins of all the world?

Further, how can another bear the penalty of our sins, when, in any case, that penalty is always exacted from ourselves? The theory plays into the hands of those thoughtless people who always imagine that forgiveness means escaping the penalty of sin. I hold that the penalty of sin is never evaded. Forgiveness restores relationship. It never remits penalty. Forgiveness changes the nature of the penalty from the soulless retribution of a moral universe to the healing discipline of a loving Father. Even if we refuse to use the word "penalty," we must use the word "effect." Every cause has its effect, and he who sins suffers, and no suffering on the part of anybody else will bring about his escape from all the efforts of causal sin. It *ought* not to do so. It *must* not do so in a moral universe.

The theory plays again into the hands of those psychologists who sneer at Christianity as an escapist neurosis, as the flight from reality on the part of the soul who is not man enough to face up to the consequences of what he has done. Here is the frightened soul again trying to "lay his sins on Jesus." If it were possible, it would be immoral. But I have never met anybody who has sinned and has not suffered, and the moral structure of the universe ruthlessly supports Paul when he says, "Whatsoever a man soweth, that shall he also reap." [11] We always pay for our sins—though not in full, as we shall see—and the nature of sin precludes anyone else from paying it for us, since literally there is no such thing as sin, but only a sinful person; just as there is nothing isolatable called "goodness," but

[11] Gal. 6:7.

only a good person. Man's sinfulness is part of himself. As William James used to say, "The molecules of his brain have registered his sins against him." His sin is part of his whole being, and his whole being cries out for redemption. The grand and mighty task to which our Lord committed himself was to save men from sinning, not to make men feel, whenever they sinned, that they would escape the consequences because of his death on Calvary; to save men, not from "sins" which are like the rash on the skin, but from being sinful persons, by cleansing, as it were, the poisoned blood stream which sets up the rash. One penalty he does save us from—our permanent estrangement from God—but not from the penalty in terms of the effects of causes within our own personality, effects which, in some cases, are physical.

4. Fourth, and closely allied to the last group of theories, are those revolving round such words as "expiation," "satisfaction," and "propitiation," used in the Communion Service. These words suggest the idea, which we have noticed already, that the sufferings of Christ are, as it were, entered on the credit side of man's account with God, and that they balance the sin of man entered on the debit side. Man now has had his debt to God paid off by Christ and is free to be reconciled with God.

We may note some truth in these words. They show once more that winning men to God is costly, but I don't think they carry the plain man far for the simple reason that their use creates more difficulties than it solves. In fact, we can get at the truth behind the language only by making the latter mean something unintended by those who made the language current coin, or, in other words, by

making these terms mean something other than their use by the plain man in a plain manner would suggest.

a) To "expiate" means to "pay the penalty of." That, we have just seen, cannot be done by another in the case of sin. If guilt cannot be transferred, then what another suffers through our sin may be very terrible, but, if words are used accurately, it cannot be a *penalty*, for that other has done nothing penal. The sharing of the shame of sin which he knows who loves the sinner, and who comes to his help in loving self-identification, is an experience amounting to agony; but still that suffering is not, in any true sense of words, paying a penalty.

b) "Satisfaction" means in plain English that there is a measure of suffering regarded as the equivalent of the affront to God which sin makes. But this is nonsense to the plain man. First, it would make God like the less-attractive humans. If my child "sins" and is sorry, effects may well follow, but *I* don't demand suffering on his part, far less on the part of any other, as *satisfaction*. What satisfaction is it to me? "Satisfaction" suggests the pagan gloating revengefully on another's sufferings. One is reminded of those old barons who kept victims in dungeons below the dining hall that their groanings might give the victors a greater joy and a deeper satisfaction. Further, this balancing up of sin and suffering is unreal, as we have seen already.

In regard to both these words, "expiation" and "satisfaction," there is another much deeper psychological objection. If our sins have really been "expiated" and if "satisfaction" has really been made to God, then the ledger is already balanced and there is no need for forgiveness. If

I owe a debt to ~~Mr. Jones~~ and you graciously come along and pay it, I may feel rather ashamed at letting you pay it, but I have no need to ask the forgiveness of Mr. Jones. He has got his money. The deal is completed.

c) The word "propitiation," as in the text, "He is the propitiation for our sins," [12] takes us away again into heathen rites. A propitiation is a means of appeasement, a means of buying off the wrath of a god. I know the scholars interpret it differently. Professor C. H. Dodd says the word means "a means by which sin is forgiven." [13] Dr. William Temple says it means "the meeting place of God's love and man's sin." [14] Principal McCrea points out that there are two Greek words for it. Just so. But the plain man who meets it in his prayer book thinks of it in terms of its dictionary meaning. The word suggests that God's anger at man's sin could be bought off if a victim could be found on whom the wrath could be vented, so that the demand for vengeance could be "satisfied."

I shall be accused of not being fair to the New Testament use of these words. But my point is, I am trying to see the matter as the plain man sees it; and when he reads his New Testament, he usually cannot look up a commentary to see the way scholars interpret New Testament words. He has the sensible habit of taking words to mean what they say. I am not saying that these words are valueless. I am saying that to retain their use, as if the matter could not be put in the language which the plain man uses,

[12] I John 2:1.
[13] *Commentary on the Epistle to the Romans*, p. 54.
[14] *Christian Faith and Life*, p. 78.

is to deny him the maximum help which he could be offered in understanding the Cross.

It may be noted that our Lord himself did not use any such word as "satisfaction," "expiation," or "propitiation," although, as Appendix I shows, there are in the Gospels fifty references to his death.

d) The word "substitution" is often used, and the phrase "Christ died for us" is used to mean "instead of us." As Dean Matthews says, "By his suffering our Lord did make it possible for us to avoid suffering continual alienation from God and the consequences of this: and therefore in a sense his suffering is substituted for ours." [15] But only "in a sense"; and when the word "substitution" lies at the heart of a theory of the Atonement, the plain man is put off because he doesn't see how Christ the innocent can be substituted for us, how it can be regarded as justice to effect such a substitution, or how the setting of such a substitution can be imagined, since neither God's relation to Christ nor God's relation to us can be adequately illustrated by metaphors which belong to the police court rather than to the relationships between the Father, the beloved Son who does his Father's will, and the children of God's world-wide family.

Newer Theories

We come now to more modern conceptions. Tired and bewildered by endless controversy, the plain man has been content to think in terms of more modern words like "example," "martyrdom," and "revelation."

True, Jesus is the greatest example in history of the way man should react, even to experiences of horror and cir-

[15] *Op. cit.,* p. 80.

cumstances which make the ultimate demand of life itself upon him. I am not one of those who despises this exhortation. The word "example" occurs in the New Testament. It is part of its message. "I have given you an example," Jesus said.[16] If a man sets Christ before him and daily exercises his will to become Christlike, then that example will indubitably inspire him, and good will result. But the onus is on man. The influence of Christ is subjective. He remains the great teacher, teaching by his life and words and by his death and example. But the onus of learning is on us. No mighty deed is done for us, and reverently it may be said that the world is indeed in a bad way if the only hope of its redemption is that each individual will one day take Christ as his example.

When we are told that Christ was the perfect martyr to a great cause, the argument is in the same category. "He sacrificed himself in the cause of goodness," the argument runs. He was the greatest of the noble army of martyrs. We are to follow him and do the same. When the captain leads out his men in some desperate military exploit and falls dead, giving his life in the enterprise, his men, inspired by his courage, respond to the challenge of his death and give themselves in the same cause, even unto death.

Both words are relevant, and both are gloriously true, and the matter could be set out at length and in such a way as to seem of vital importance. But I am content to deal with it briefly because in my heart I believe that, compared with the central truth, it may almost be brushed aside. When a distinguished minister died the other day, an obituary notice said, "He left behind the inspiration of a noble example." The words seemed adequate enough. But how in-

[16] John 13:15.

adequate they would be in reference to Jesus! To dismiss the Crucifixion as if it were no more than a lovely example of human courage, or a heroic martyrdom in a fine cause, is almost to insult the records in the New Testament and to leave some of the most important questions unanswered.

We draw a little nearer when we think of a phrase often used in these days of a man in the armed forces who lays down his life. We say, "He died for his country." Let us ask what this means! It does not mean he died instead of his country. It means he loved his country so much that, for her sake, to help protect her from forces that, if successful, would have made her cease to be the country he loved, he was willing to lay down his life. So Nurse Cavell "died for England," not "instead of England," not in any sense connected with the words "expiation" or "satisfaction" or "propitiation"; but she died in expressing those values which make England the country we love. But she revealed the nature of patriotism in a way which has inspired us all, helping us to make her values our own. Thus a deed done in time and in one place has inspirational value for all time and all places. We are closer there to the meaning of the Cross, for Christ's death, in time and in one place called Calvary, has value for all time and all places; but, if this be all, is it a value deeper than is covered by the word "inspirational"?

My view is that when one has said that, one has not gone nearly far enough, for still the influence of the deed is subjective, not objective. Its power is limited to our response of feeling, and that response is not enough to break the power of sin in our hearts. Indeed, injustice creeps in, for

many people of a phlegmatic temperament are not greatly influenced by feeling. It would be a grievous mistake to argue that salvation depends on emotional response, for the latter often depends not only on mental but on physical factors in the individual.

Finally, we must consider the Cross as a revelation of God's love. Now we are getting warmer still, for none of the objections hitherto noted undermine our point of view. We do not by this view separate the Father and the Son; we are not asked to believe in anything unjust, or in the fictitious transfer of guilt.

The argument can be put briefly thus: A good man, to the extent to which he is good, is a revelation of the nature of God. A perfectly good man perfectly reveals the nature of God, inasfar as that nature can be revealed in one who remains perfectly human. Therefore in Jesus we are looking at God. "He that hath seen me hath seen the Father." [17] In the reaction of Jesus to sin, then, we see the reaction of God to sin. It meant condemnation, but it meant suffering. It meant no reprisals, no violence, but to go on loving and loving and loving until man, seeing what sin cost God the only Lover of souls, turned in horror from his sinful ways and began a new life. What sin cost Jesus in terms of human suffering, so it now costs God in mental and spiritual suffering beyond our power to estimate.

> I sometimes think about the Cross,
> And shut my eyes and try to see
> The cruel nails and crown of thorns
> And Jesus crucified for me.

[17] John 14:9.

101

But even could I see him die,
 I could but see a little part
Of that great love which like a fire
 Is always burning in his heart.

I have worked out this argument more fully elsewhere [18] and will not dwell on it here. It is a powerful argument. It has truth and cogency. It leads often to penitence, and it has converting power. "Look what your sin costs God," it cries. "How *can* you go on wounding like this the Love that suffers to the uttermost, a Love that will never let you go, and yet which you can refuse and wound again and again?"

Yet while I glory in this awesome truth, I know in my heart that it is not the center of the matter. This view that the death of Christ is a perfect revelation of the nature of God and of his reaction to sin, and that such a revelation compels obedience, goes a long way, but it does not go far enough. It doesn't go as far as the New Testament language takes us.

The inadequacy does not seem to me very different from certain methods of psychotherapy which I regard as insufficient. It is not uncommon to find a psychoanalyst who will dissect the mind and analyze down to the cause of the disharmony; and when the patient, after many interviews, has discovered that the treatment has laid bare the cause of all his troubles, the analyst's subsequent comment seems to be, "Now I have revealed to you what is the matter; get better." But how to get better and what adjustment to make, and how to make it, is not explained to the patient.

[18] *His Life and Ours*, pp. 254 ff.

The treatment stops at revelation. In this way so much psychoanalysis earns for itself the bad name which it has for so many people, for what is subsequently required is psychosynthesis. What is needed is putting Humpty-Dumpty together again, and in my own mind I feel quite certain that this simply cannot be done without reference to God, and concerning God that kind of psychoanalyst is dumb.

I feel it a weakness in the preaching of the Cross if I can only say to people—though even this is a great thing to say —that "when we sin it is as though we drove the nails through his hands. We are fighting against infinite Love. We are making God suffer. Surely when we see this we must stop sinning and refrain from it and become as he would have us." You notice that the emphasis is left on *our becoming* as he would have us, and I am sure there is a deeper and richer word for us in the Cross than this, which I shall try to deal with later. "God does not redeem us," says Dr. Dale, "merely by revealing his love. He reveals his love by redeeming us." If I jump into the water to save your child, I reveal my love for you and for the child, but I do not jump into the water to reveal my love, and the revealing does not save. I jump into the water to save the child. A mighty doing is essential.

I think we shall find that, although we may not use the words which our great-grandfathers used to describe a transaction, we shall find that the transactional idea, even the substitutional idea, when expressed rather differently, is possibly nearer to the truth than we imagine. Great power is set free in men's hearts when the love of Christ is revealed to them in all its power, but something would

have happened to us that has not happened because of something which Christ *did*. It is that mighty doing that lies at the heart of the message of the Cross, and to stop at revelation leaves something unsaid which ought to be said, something which was about all the early church cared about saying, something which is perhaps the most important truth in the world.

CHAPTER VI

The Cost of Our Deliverance

IN THIS chapter we seek to draw nearer to the very center of the message and meaning of the cross. One knows that failure to understand is certain. The implications of the Cross of Jesus Christ are beyond the mind of man. Here is impenetrable mystery, a love greater than our little hearts can compass, even in imagination, a wide-sweeping purpose broader than the mind of man can contemplate. Truly

> . . . the love of God is broader
> Than the measure of man's mind,

and the mystery of the Cross is the mystery of the love of God.

The task to which Christ committed himself we call the redemption of the world, by which we mean the task of winning the hearts of men and women from evil to good, from darkness to light, from the power of Satan unto God, from the ugly things that destroy to the lovely things in which is man's truest life, to the enthronement of God instead of that of self, to reconciliation and peace.

Christ's Self-Emptying and Agelong Humanity

Our first section I have called "Christ's Self-Emptying" because I am sure that we shall not get far in the attempt to

understand the Cross unless we begin with the thought that Jesus Christ was and is a divine person. Without a belief in Christ's divinity the message of the Cross is only a message about a brave man who died for a great cause. Man is left in his sins. I believe "in one Lord Jesus Christ, the only-begotten Son of God, begotten of his Father before all worlds, God of God, Light of Light, very God of very God, begotten, not made, being of one substance with the Father, by whom all things were made; who for us men and for our salvation came down from heaven, . . .

AND WAS MADE MAN."

Those who believe that Jesus was only a good man and merely human must make what sense they can of the Cross. I think they will be in great difficulties and may not be able to get much further than the three words we recently studied. They will conclude that Christ was the world's most noble martyr, the world's most shining example, and the most perfect revelation of the nature of God which the world has ever known. But his death, taken as a historical fact, and taken right out of the context of his life before it and after it, has no unique meaning. The meaning of his death is disclosed to no one completely. But to those who assert that he was only a good man I think it is wholly obscured. It is only in the light of what Christ was and is that we even begin to understand.

Indeed, those who think of him as only a man may not even get as far as thinking of him as the perfect example; for, as we noticed on page 63, there was, on the part of our Lord, a strange shrinking from the Cross, whereas his followers were crucified with what appeared a greater cour-

age, and many of them suffered agonies as terrible and pro-
longed as the horrible anguish of crucifixion.

To solve this last-named problem some facts might be
advanced:

a) He led the way. He was the first to suffer for the
new faith. It was easier for others to follow because he had
led the way.

b) His was a greater sensitiveness to suffering. We all
realize that the unimaginative, stolid, burly, and phlegmatic
type of man can bear physical and mental pain with less
cost than has to be paid by the man of sensitive feeling,
deep sympathy, and the power of imaginative identifica-
tion.

c) The shrinking from the Cross may partly be ac-
counted for by the thought in the mind of Jesus of all the
sin and suffering in which his being put to death would
involve others. What an eternity of woe in the minds of
those who put him to death, and whose anguish of subse-
quent remorse we cannot even imagine, would have been
prevented if God had answered the prayer in the Garden
that the cup might be removed. The fact that this was on
his mind is shown by his own wonderful word as he was
being nailed to the Cross, "Father, forgive them; for they
know not what they do." [1] It is further evidenced by the
reflection that a perfect person suffers more acutely in the
sins and sorrows of others than through any sufferings
which are his alone.[2]

[1] Luke 23:34.
[2] I am afraid I disagree with Dr. Maltby that Jesus deliberately in-
vited physical death because he realized that his body could not much
longer stand the strain of the burden laid upon him. Dr. Maltby says:
"He was pressed to the very edge of physical collapse by an inward

Yet even the cumulative effect of these three arguments does not, in my view, explain the shrinking. For this we must go much deeper and contemplate—though we have a frail equipment to do so—the preincarnate life of Christ and something of what his self-emptying meant.

Let us think now, therefore, not of a man, however noble and heroic, who walked the streets and lanes of Palestine two thousand years ago, who became a menace to the tranquillity of both state and church, and who by foul and unjust means was done to death. Let us begin with the thought of a Divine Being, the second person in the Holy Trinity, who dwelt in the bosom of the Father, in whom dwelt "all the fullness of the Godhead bodily." [3] That preincarnate life was inexpressibly precious. On the night before his death he prays, "And now, O Father, glorify thou me with thine own self with the glory which I had with thee before the world was." [4] We cannot imagine what this life was like, but we are not at liberty to attempt an interpretation of his redemptive work by leaving it out. We have referred already to that moving and mysterious pas-

sorrow which had nothing to do with bodily pain, but only with the sin of men whom it was his to save. Jesus, then, knew that one way or another death was near. He knew that, however it came, it would come from men's sin. . . . And, since he knew also by now that it was the will of God that men should do with him what it was in their hearts to do, and death therefore should come to him that way . . . he went up to Jerusalem to challenge their sin and to accept death at their hands." (*Christ and His Cross*, pp. 89 f.) I cannot accept this, on the ground that if Jesus had known that, being at the end of his physical strength, he was about to collapse and die of exhaustion, he would have allowed himself to do so, for in this way he would have saved his persecutors from the awful guilt they incurred by putting him to death.

[3] Col. 1:19.
[4] John 17:5.

sage in which Jesus said that Abraham had "seen his day," and added, "Before Abraham was, I am." [5] Jesus himself furnished the evidence for our belief in the reality of a preincarnate, precious, and limitless life.

The point to which we then move, in trying to understand the Cross, is that of the Incarnation, which began, as Warburton Lewis has so aptly said, when Mary said, "Into thy hands I commit my body," and ended when Jesus said, "Into thy hands I commit my spirit."

The Incarnation is also a mystery far beyond us, but, without in any way comprehending it, we must try to reckon with the immeasurable sacrifice which it entailed. Even the poets cannot say this for us, though hundreds have tried. Says Milton:

> That glorious Form, that Light insufferable,
> And that far-beaming blaze of majesty,
> Wherewith he wont at Heaven's high council-table
> To sit the midst of Trinal Unity,
> He laid aside.

An Indian poet, Narayan Varnan Tilak, says:

> Thou dwellest in unshadowed light,
> All sin and shame above—
> That thou shouldst bear our sin and shame,
> How can I tell such love?

> Ah, did not he the heavenly throne
> A little thing esteem,
> And not unworthy for my sake
> A mortal body deem?

[5] John 8:58.

109

> So Love itself in human form
> For love of me he came.

A homely hymn we sing at Christmastide says:

> Thou didst leave thy throne and thy kingly crown,
> When thou camest to earth for me.

Only by using words like these can we indicate the immense sacrifice which our Lord made.

I think it was Mr. C. S. Lewis who first helped me to glimpse something of what it meant, by asking his listeners over the radio whether, for any reason at all, they would be willing to enter the prison of some lower form of life. Let me put it thus to the reader. You are sitting in your armchair by the fire, or perhaps in some sunny garden. You have your home, your work, your dear ones; you have your culture, your intellect, your taste; you have your music, your art, your literature. Lying at your feet is your dog. Imagine, for the moment, that your dog and every dog is in deep distress. Some of us love dogs very much. We know that they have it in them to become in a wonderful way the friends of men, to develop devotion and fidelity and sympathy and amazing companionship. Many of us would prefer to spend eternity with some dogs we know rather than with some people we know. Those honest, eloquent, brown eyes, gazing so trustfully into our own, sometimes mournfully, sometimes roguishly, but always with understanding, and that wet nose thrust into our hand when sorrow or despair overwhelms us—how much they mean! If it would help all the dogs in the world to become like men, would you be willing to become a dog? Would you put down your human nature, leave your loved ones,

your job and hobbies, your art and literature and music, and *choose*—instead of intimate communion with your dearest—the poor substitute of looking into the beloved's face and wagging your tail, unable to smile or speak? Christ, by becoming man, limited the thing which to him was the most precious thing in the world, his unhampered, unhindered communion with God the Father. Or, since man is made in the divine image, and men are said to have developed from a species of monkey, let us change the illustration and ask the same question. Would you be willing to become a monkey and live with monkeys for monkeys? Would you exchange your ways and habits for the life you see in the monkey cage at the zoo? Even if you would, you would not do what Christ did, for you would only exchange one flesh for another flesh, one place for another place, one limited life for another.

What a hush falls upon the spirit when we even try to understand what happened when the eternal Son became man! Pure, unhampered, infinite spirit in the bondage of a human brain, human instincts, and human flesh! Omnipresence surrendered to the narrow prison of space! A Timeless and Eternal Being in the prison of time! Limitless communion with the Father given up for the prison of limited knowledge [6] and the separation from the Father which a true humanity must have imposed at this point and at that. Paul puts the matter nobly: "Though he was divine by nature, he did not set store upon equality with God, but emptied himself by taking the nature of a servant; both in human guise and appearing in human form, he humbly

[6] "Of that day and hour knoweth no one, not even . . . the Son, but the Father only." (Matt. 24:36.)

stooped in his obedience even to die, and to die upon the cross." [7]

"All things were made through him," says the Gospel. [8] Look up one perfect night at the sky and behold the Milky Way! Read what the astronomers say about the heavens, and ask what it meant for the one who was most concerned in their creation to tread the dust of this wayside planet we call the earth, to be limited to the flesh and brain of one of its insect-creatures, to live in the back streets of a dirty little Eastern town called Nazareth.

Slowly, in this truly human personality, God ordained for Christ the dawning consciousness of who he was. It could not have been done suddenly. The brain of a boy at Nazareth, for example, could not possibly have stood the strain. We rightly call a person insane who believes himself God. But this person shows no symptom of insanity. If this is insanity it is preferable to our mental health. Once the full knowledge was his, he must have longed, with a longing we can never understand, to be reunited with his Father in that preincarnate glory. Was the sentence, "Glorify thou me with . . . the glory which I had with thee before the world was," [9] a prayer to go home? No lonely schoolboy longing for home, no lassie sobbing in a strange "evacuated" home, soaking the pillow with midnight tears, need fear but that the human Christ knows that feeling in an intensity of degree beyond our power to imagine.

How illuminating it is, therefore, that in Matthew's ac-

[7] Phil. 2:6-8 (Moffatt).
[8] John 1:3.
[9] John 17:5.

count of the garden agony we have the words, "He . . . began to be sorrowful and sore troubled," [10] or, as I have somewhere seen the words translated, "He . . . began to be sorrowful and *very homesick*." I believe that the dread and awe-ful truth is that the mind of Jesus, which because of its human limitations was made aware only from step to step of the Father's will, became aware in the Garden of Gethsemane that even the Cross was not the end, but in a sense the beginning of a new burden, the burden of a continued humanity, a continued ministry on the other side of death. Let me put it in schoolboy English—*He wasn't allowed to go home.* He laid down his flesh on the hard wood of the cross, but he did not resume the glory of godhood, the equality with God which he had with his Father before all worlds. He remained human that he might carry on a ministry which even the Cross did not conclude.

What an awesome and terrifying prospect was before him! Is it any wonder that in the Garden of Gethsemane he reeled beneath the blow of this revelation of his Father, shrank from its implications, and developed a symptom which doctors tell me has been observed before and since in cases of extreme mental agony, the extravasation of blood through the pores of the skin? "His sweat became as it were great drops of blood falling down upon the ground." [11] He had to continue in the human school of life until all his little brothers graduated. He became "the firstborn among many brethren," [12] never to desert the family until all its members could be offered to God, reborn into

[10] Matt. 26:37.
[11] Luke 22:44.
[12] Rom. 8:29.

the family of the redeemed, a family complete and perfected. He escaped at death from the prison of time and space. He escaped the bondage of the flesh. But not from the burden and limitation of our humanity. In that dread hour in the Garden of Agony he was made willing to face imprisonment in an agelong humanity, even though he longed to return to his Father in the fullness they knew together before sin darkened even the joy of heaven. Only a divine love could face it. But he did it for us and for all men, and "breathless with adoration" we begin to see part of the cost of our deliverance from the power of sin. His shrinking from the Cross, then, I take to be the first shock of sin in man, so deep and long-continued that the task of redemption involved his agelong imprisonment in humanity, involving a measure of separation from God while all he essentially was cried out for the unity he had with God before time began. Yet, even so, his shrinking from the Cross was in no sense selfish or merely personal. It was caused by his sudden realization of the awfulness of human wickedness as a thing that even he could not deal with in a lifetime on earth. It would take even him an agelong ministry of self-renunciation to achieve man's redemption.

> The awful sorrow of his face,
> The bowing of his frame,
> Come not from torture nor disgrace:
> He fears not cross nor shame.
>
> There is a deeper pang of grief,
> An agony unknown,
> In which his love finds no relief—
> He bears it all alone.

> He sees the souls for whom he dies
> Yet clinging to their sin,
> And heirs of mansions in the skies
> Who will not enter in.

The truth of Christ's persisting humanity after death I take to be part of the inwardness of the Ascension. They saw the human Jesus ascend, and believed that same human Jesus would return. Let Luke's words carry their full weight:

A cloud received him out of their sight. And while they were looking steadfastly into heaven as he went, behold, two men stood by them in white apparel; which also said, Ye men of Galilee, why stand ye looking into heaven? this Jesus, which was received up from you into heaven, shall so come *in like manner* as ye beheld him going into heaven.[13]

Browning has scriptural basis for his lovely lines:

> 'Tis the weakness in strength, that I cry for! my flesh, that I
> seek
> In the Godhead! I seek and I find it. O Saul, it shall be
> A Face like my face that receives thee; a Man like to me,
> Thou shalt love and be loved by, forever: a Hand like this hand
> Shall throw open the gates of new life to thee! See the Christ
> stand![14]

I am especially eager—even at the cost of repetition— that we should really grasp this truth of Christ's continued humanity. We ourselves so identify the physical body with our human nature that many of us have come to think that when Jesus ascended to heaven and discarded his body, he resumed his preincarnate glory and his equality with God,

[13] Acts 1:9-11.

[14] "Saul." Not literally "my flesh." Browning uses the word as the symbol of true humanity.

the glory which he had with his Father before all worlds. But I am quite sure that this is not the message of the New Testament. When we lay down our body, we do not cease to be human; and when Jesus laid down his physical body, he did not cease to be human either. It is not merely true to say, "He became flesh," or that God took our flesh. He took our whole nature. The truth is, "He became man," and man is more than flesh. Indeed, man is essentially not flesh at all, but spirit. What the limitations of a human spirit are after death no one can say. Certainly no one can say what the limitations of Christ were or are, either before death or after. But the truth must be retained that after his resurrection he was certainly still divine *but also still human.* Wherever he was recognized, after the Resurrection, he was recognized as human—the same dear Lord they had known and loved. He was changed, and he had new powers, but he took pains to prove his humanity. "Why are ye troubled? and wherefore do reasonings arise in your heart? See my hands and my feet, that it is I myself: handle me, and see; for a spirit hath not flesh and bones, as ye behold me having. And when he had said this, he showed them his hands and his feet." [15] I know that this passage has been declared unauthentic by the scholars. I accept their finding; but its inclusion in the gospel narrative proves that the early church believed tenaciously in the humanity of Christ after his death and resurrection, even though, as we think mistakenly, they identified humanity with flesh. He did not, in my view, literally "take to heaven a human brow," but Jean Ingelow's poem is very precious to me. Figuratively and poetically it states a most important truth.

[15] Luke 24:38-40.

And didst thou love the race that loved not thee?
 And didst thou take to heaven a human brow?
Dost plead with man's voice by the marvelous sea?
 Art thou his Kinsman now?

O God, O Kinsman loved, but not enough,
 O Man, with eyes majestic after death,
Whose feet have toiled along our pathways rough,
 Whose lips drawn human breath!—

By that one likeness which *is* ours and thine,
 By that one nature which *doth* hold us kin,
. .
 I pray thee, visit me.[16]

He does "plead with man's voice by the marvelous sea." "He ever liveth to make intercession for us." [17] And he has not even yet repudiated his kinship. He is part of humanity. He is still a member of the family, the first-born of many brethren. His humanity was not a disguise which he threw off at death. He took it with him into the other world. As Bishop Wordsworth said:

He has raised our human nature
 In the clouds to God's right hand;
. .
Jesus reigns, adored by angels;
 Man with God is on the throne.

It was this same truth of his continued humanity after the laying down of his flesh which I suppose our fathers sought to conserve in the fourth of the Thirty-Nine Articles in the Prayer Book: "Christ did truly rise again from

[16] Note the present tense of the words I have italicized.
[17] Heb. 7:25.

death, and took again his body, with flesh, bones, and *all things appertaining to the perfection of man's nature;* wherewith he ascended into Heaven." It sounds crude language now, and we realize perhaps more clearly that human nature is essentially spirit. We need not believe in the idea that Christ's material body of flesh and bones ascended.[18] As Paul himself said, "Flesh and blood cannot inherit the kingdom of God," [19] and the body of the risen Christ was not the flesh and blood we know, for it passed through closed doors. What the language in the Articles about his body and bones sought to emphasize was his continued and real humanity. And this same truth made Charles Wesley write:

> The dear tokens of his passion
> *Still* his dazzling body bears.

This, then, is the first factor that we must realize in our attempt to understand the cost and manner of Christ's redemptive work. The infinite God became man, and not only dwelt among us "full of grace and truth," to live a life of service and to die a death of shame—not wearing the disguise of humanity and throwing it off at the Ascension —but became man *in spirit as well as in body*, while remaining divine, and pledged himself to remain a member of the human race until the task of man's redemption was completed.

Christ's Self-Dedication and Betrothal to Humanity

When we considered the words which Jesus used about his own death, I purposely omitted one, partly because it

[18] See *His Life and Ours*, p. 287.
[19] I Cor. 15:50.

is not usually associated with death and partly because I want to discuss it more fully here. It is the word "bridegroom." He used it more than once, and I believe that to the early church the metaphor meant much more than it does for us. We lose a precious truth by neglecting it, and to discuss it will carry our thought a stage further. I must first try to show that it is not fanciful to suppose that the metaphor of the bridegroom meant a great deal to the early church.

When his men were criticized for their careless ways in the matter of refusing to fast, Jesus said, "Can the sons of the bridechamber fast, while the bridegroom is with them? as long as they have the bridegroom with them, they cannot fast. But the days will come, when the bridegroom shall be taken away from them, and then will they fast in that day." [20]

These words occur very early in the three Synoptic Gospels, and therefore I am not convinced that in using them Jesus was definitely thinking about his death. I quote them only to show that, even in those early days, our Lord used the figure of the bridegroom in speaking about himself. Indeed, so early does the passage occur in Mark, the earliest Gospel, that some critics regard the second and third sentences quoted above as a later addition. Another explanation of the early occurrence of the words about the bridegroom's leaving them would be to regard Jesus as referring to his death in the sense of the inevitability of death which every man confronts. The saying may be a reference to his death, but not to his death upon the Cross. Dr. Vincent Taylor says: "It is unfortunate that the saying

[20] Mark 2:19-20; cf. Matt. 9:15; Luke 5:34-35.

cannot be dated with any precision, since it belongs to a section [Mark 2:1–3:6] which is arranged topically, and which probably existed as a connected whole at the time when Mark wrote his Gospel." [21] At any rate, we see Jesus using the figure of the bridegroom to describe himself.

Then in the twenty-fifth chapter of Matthew we have the significant parable of the ten virgins who were to meet the bridegroom.[22] "The bridegroom tarried"—a significant comment on the delayed Second Coming for which the early church hoped! But at last the bridegroom came, and the feast followed. Now this parable is especially significant and appropriate to Passover time, and we note how late in the Gospel it occurs. Its appropriateness lies in the fact that the marriage symbolism in the parable, if spoken at Passover time, would remind our Lord's hearers that not only did the Passover Feast commemorate the historic deliverance from Egypt, but it was thought of as the marriage between God and Israel. Professor J. Alexander Findlay quotes a saying of the ancient rabbis as follows: "Moses came to the children of Israel and said, 'Behold, the bridegroom cometh, come ye forth to meet him.' " [23] It was probably from this source, I presume, that our Lord quoted the words, and the idea was certainly not a new one.

The prophecy of Hosea makes use of the same figure. Hosea had a faithless wife, whom he was tempted to cast away from him. "Plead with your mother," he says to her children, "for she is not my wife, neither am I her husband: and let her put away her whoredoms from her face, and

[21] *Jesus and His Sacrifice*, p. 84.

[22] Matt. 25:1-13. I have discussed this parable in *In Quest of a Kingdom*, chap. xix.

[23] In an article in *The British Weekly*, May 28, 1942.

her adulteries from between her breasts; lest I strip her naked, and set her as in the day that she was born, and make her as a wilderness, and set her like a dry land, and slay her with thirst; yea, upon her children will I have no mercy; for they be children of whoredom. For their mother hath played the harlot." [24] But in a mood of great compassion the prophet changes his mind. He determines to speak comfortably to her. "I will . . . speak comfortably unto her. And I will give her her vineyards from thence, and the valley of Achor for a door of hope." [25] And in this new attitude Hosea sees the attitude of God to his people. They had sinned like an unfaithful wife. But he says, "I will *betroth* thee unto me forever; yea, I will *betroth* thee unto me in righteousness, and in judgment, and in lovingkindness, and in mercies. I will even *betroth* thee unto me in faithfulness: and thou shalt know the Lord." [26]

We know how our Lord brooded upon the Old Testament Scriptures and saw his own attitude to the people he had come to save revealed in the attitude of the noble prophets. To take a well-known example, there is not the slightest doubt that he saw himself in the words used in Isaiah 53. May we not suggest that he saw himself in the attitude revealed by Hosea's language? He was the bridegroom *betrothed* to his people.

In this context we must not miss the words of John the Baptist: "Ye yourselves bear me witness, that I said, I am not the Christ, but, that I am sent before him. He that hath the bride is the bridegroom: but the friend of the bride-

[24] Hos. 2:2-5.
[25] Hos. 2:14-15.
[26] Hos. 2:19-20; cf. Jer. 2:2.

groom, which standeth and heareth him, rejoiceth greatly because of the bridegroom's voice: this my joy therefore is fulfilled." [27] This is an undoubted reference, on the part of John the Baptist, to the role of our Lord as bridegroom, and shows that the idea was familiar to others besides our Lord himself.

In fact, I hazard the view that the word "bridegroom" was a favorite metaphor which Jesus used about himself. The early church certainly reveled in applying to itself the word "bride," and in the article already quoted Dr. Findlay points out that the washing of the bride's feet formed part of a Jewish wedding ceremony. He adds, "Jesus washes his disciples' feet to make them worthy successors of the true Israel, the bride of God."

Since, on the same evening, Jesus used another word which occurs in a Jewish marriage ceremony, the word "covenant,"—"This cup is the new covenant in my blood" [28]—one wonders whether, in our Lord's mind, the whole of the closing events of his last hours on earth, from the feet-washing to his death, including the supper of which he said, "With desire I have desired to eat this passover with you," [29] were not regarded by him as his "marriage" to humanity, just as the original Passover was regarded as God's "marriage" to Israel.

We remember that John sees the new Jerusalem, the community of the redeemed, coming down out of heaven from God as a *bride* adorned for her husband, and this community is constantly called "the wife of the Lamb." [30]

[27] John 3:28-29.
[28] Luke 22:20.
[29] Luke 22:15.
[30] Rev. 21:2, 9.

Paul is familiar with the same theme: "The husband is the head of the wife, *as Christ . . . of the church*." [31] "I espoused you," he tells the Corinthians, "to one husband, that I might present you as a pure virgin to Christ." [32] And to the Ephesians he writes, "Husbands, love your wives, *even as Christ also loved the church, and gave himself up for it*." [33] Today, in the marriage service, we tell the bride and bridegroom that their marriage signifies "the mystical union which exists between Christ and his church," and later, in one of the prayers, we pray that the husband may love his wife "as Christ did love his spouse the church, who gave himself for it, loving and cherishing it even as his own flesh."

Some compilers of hymnbooks have disapproved of calling Jesus by the title "husband," but John Newton's lovely hymn originally contained the line: "Jesus my Shepherd, *Husband*, Friend."

Here we have a theme which, to my mind, takes us an immense distance. For does this heavenly Bridegroom ever forsake his bride? Can there be in regard to this marriage any thought of divorce or separation? And here, with special permission, I want to print an illustration which Dr. Maltby used in a pamphlet called *The Meaning of the Cross*, to which I have made reference in the Preface:

The writer knew a working man in the North of England whose wife, soon after her marriage, drifted into vicious ways, and went rapidly from bad to worse. He came home one Sunday evening to find, as he had found a dozen times before, that

[31] Eph. 5:23.
[32] II Cor. 11:2.
[33] Eph. 5:25.

123

she had gone on a new debauch. He knew in what condition she would return, after two or three days of a nameless life. He sat down in the cheerless house to look the truth in the face and to find what he must do. The worst had happened too often to leave him with much hope, and he saw in part what was in store for him. He made his choice to hold by his wife to the end, and to keep a home for her who would not make one for him. Now that a new and terrible meaning had passed into the words "for better, for worse," he reaffirmed his marriage vow. Later, when someone who knew them both intimately, ventured to commiserate him, he answered, "Not a word! She is my wife, and I shall love her as long as there is breath in my body." She did not mend, and died in his house after some years, in a shameful condition, with his hands spread over her in pity and in prayer.[34]

That is a splendid illustration of a human love that goes further than most in these days of easy divorce. But there came a time of release for that loving husband, namely, the death of the wife.

But supposing the husband had died first. Supposing, as might easily happen, that her fiendish behavior had been the cause of her husband's death, and *supposing he still loved her.* Would he, reveling in the separation which death effected, wash his hands of her and have done with her? If he still loved, would he not dedicate himself to her again on his very deathbed, and would he not in that other world both pray for her and use any new-found powers that heaven provided to win her to a new and clean life? There is no doubt about the answer. If he still loved her sufficiently he would.

Let us apply the illustration. We have thought of Christ

[34] P. 12.

as the Bridegroom, giving himself even unto death for the bride. But though men killed the Bridegroom by their evil ways, they could not kill his love, and we find him in the Garden of Gethsemane facing the prospect of ministering to us in the same costly fashion, with all the wider powers the other world might bring him. So we watch the divine Son passing from life on this earth to life on another, maintaining his humanity and refusing to break his link with us.

Christ is doing this for every man. The picture in the Epistle to the Hebrews is grand indeed. We see the risen Christ as our great High Priest, but there is more than a priestly function involved. We are told that "he ever liveth to make intercession" for us.[35] But the Greek word does not only mean "to intercede for," or "to plead for." It includes the idea of meeting and of acting on behalf of another person to whom one is committed.[36] Jesus, by remaining man, as it were, is able to contact man with his left hand and, being God, reaches out his right and grasps the hand of the Father; and then, drawing his own hands together in the fullest meaning of the word "intercession," he links man with God. This picture seems to me behind the words, "He ever liveth to make intercession."

I see, therefore, the depth of anguish as well as the temptation of the Garden of Gethsemane—which we might almost call the third desert experience [37]—in the longing of

[35] Heb. 7:25.

[36] See Wescott, *Commentary on Hebrews,* p. 191; cf. Peake, *Century Bible* p. 162.

[37] The first being the temptations in the desert at the beginning of his ministry (see pp. 39ff.); the second the temptation at Tyre to refuse to be more than the Messiah of Israel (see pp. 49ff.); and the third the temptation in Gethsemane, with crying and tears, to refuse to undertake the costly and agelong ministry to humanity after his death.

Christ that his own death should mark release from the burden of being wedded to our humanity and from his commission to serve it. Surely he had suffered enough. Surely his own death, after he had given to the uttermost of mind and soul, as well as of body, should have set him free. Yet, as we have seen, at the point at which he might have left us with a magnificent example, he went on. He might have escaped with honor to the bosom of the Father and to the glory he had with his Father before all worlds. But he went on. This Bridegroom was wedded to the human race, and he would seek no divorce and accept no release. To quote Dr. Maltby's lovely words:

On Calvary he betrothed himself forever to the human race, for better, for worse, for richer, for poorer, in sickness and in health. . . . It is not what God once was, or Christ once did, that can save us; but what Christ once did is the sacrament and visible pledge to us of what he is and does forever, and shows to us, each one, if we will, the God with whom we have to do. . . . We know what it means to wash our hands of a person, but we have no word for the opposite thing.[38]

It was that "opposite thing" to which Jesus committed himself. He committed himself to the task of recovering all humanity to God, however long it might take, however arduous the way, however unrewarding the toil.

We begin, then, to see the cost and manner of this mighty deliverance to which our Lord committed himself, and of which the Cross is the kind of pledge which the wedding ceremony is between bride and bridegroom. In solemnity and in joy they give themselves to one another in an everlasting covenant. The blood shed on the Cross is the blood

[38] *Op. cit.*, pp. 16, 18, 12.

of an everlasting covenant. He who in life gave himself to the uttermost will in his life beyond death give himself to the uttermost and forever, and will not accept deliverance until we are delivered too. Says Rabindranath Tagore, in a passage that summarizes much of my argument: "Deliverance? Where is this deliverance to be found? Our master himself has joyfully taken upon him the bonds of creation; he is bound with us all for ever." [39]

A marriage ceremony is significant in the light of what follows it. If bride and bridegroom separated after it, it would mean but little. Similarly the historic act of dying on the Cross was not the redemptive factor in our deliverance, save that it was the pledge of his agelong giving of himself to us, the promise that he will never leave us nor forsake us. The historic crucifixion is to be compared with the wedding ceremony; but, to put it crudely, it is the living together with Christ after we have been drawn to the Cross that will win us from our evil ways and save us from our sins. This our Lord contracted to do. As he gave himself to the uttermost until, while still in a body, he could give no more, so now he still gives himself to the uttermost to all who will receive him.

Listen while Paul finishes a sentence, the first part of which we have quoted already:

Husbands, love your wives, even as Christ also loved the church, and gave himself up for it; that he might sanctify it, . . . that he might present the church to himself a glorious church, not having spot or wrinkle or any such thing; but that it should be holy and without blemish . . . because we are members of his body. For this cause shall a man leave his

[39] *Gitanjali.*

127

father and mother, and shall cleave to his wife; and the twain shall become one flesh. This mystery is great: but I speak in regard of Christ and of the church.[40]

Paul was not as squeamish in his metaphors as we are. Sex to him was the objective, healthy, natural, and truly lovely thing it ought to be to us. Paul dares to think of Christ's relationship to the church as that of a bridegroom to a bride—an intimate union so close as to produce new life. As man and wife become one flesh, *so*, says Paul, "I speak in regard of Christ and of the church." [41] He repeats the idea even more clearly: "Wherefore, my brethren, ye also were made dead to the law through the body of Christ; that ye should be married to another, even to him who was raised from the dead, that we might bring forth fruit unto God." [42]

May we not suppose that the activity of Christ within the hearts of those who receive him, and who for this reason constitute the church, is to bring to birth the new man, the new creation. The old nature sloughs away. As Paul says, the old man perishes.[43] Through a relationship closer than even the figure of marriage has power to suggest, by a mystical union of the believer with Christ the new man in Christ is born. Let us turn, then, to Christ's union with us.

Christ's Union with, and Extended Incarnation in, Humanity

We are ready now to enter what seems to me the very holy of holies in regard to the problem of the Atonement.

[40] Eph. 5:25-32.
[41] Eph. 5:32.
[42] Rom. 7:4.
[43] II Cor. 4:16.

This divine Son who gave up his unlimited godhood in order to enter the prison of flesh in a space-time earthly prison has completed the first part of his mission. The Incarnation is over. He is no longer manifested in ordinary human flesh. His earthly body has given way to a heavenly one, as we may imagine ours will, though with essential differences. He himself is still human. In all the appearances after the Resurrection, though he is not recognized at once, *when he is recognized*, there is no doubt about it. He is the same beloved, human, divine friend; the same person with whom they had walked and talked when he was in a body like their own. The two going to Emmaus were slow to recognize him, but when he broke a loaf in half in the familiar way he used to have, their hearts leaped out to the truth. And the joyous thing is that they found him still engaged in the same kind of ministry. "We hoped that it was he which should redeem Israel," they had said in despair.[44] Afterward they must have realized that, while he was talking to them, he *was* redeeming Israel through what he said to them and did for them while their hearts burned within them.

Here, then, is the real foursquare gospel: (1) a Divine Being who shares the fullness of the Godhead; (2) God incarnate, not "veiled in flesh," as the hymn says, but *manifested* in the flesh; (3) the self-giving of this incarnate Lord to the point of death by crucifixion; and (4) the continued ministry of the risen Lord in a self-giving through union with those he seeks to redeem.

It is this union at which we must now look. The word

[44] Luke 24:21.

is difficult, but I cannot find a better.[45] I need a word which shows Christ utterly human and thus able to enter into man's life more closely than man's twin brother or greatest friend, and yet a person utterly divine and thus separate from the sinner, through which fact alone he can redeem him.

Christ must be closer to the individual sinner than any word like "friendship" or "companionship" or "communion" implies. He must share the sinner's experiences, save those—like guilt—which are unsharable. But he must be distinct from the sinner or his power to save is gone. The word "union" perhaps expresses the meaning, but even that word seems to me hardly close enough to describe what Paul means by the oft-repeated phrase "in Christ." "I live," he says, "and yet no longer I, but Christ liveth in me." [46]

By a self-giving closer than words can express I believe he is so closely identified with us that he indwells each of us, glorified in the saints in whom, with less restriction, he can manifest himself, but imprisoned in our slowness to believe and *hindered, wounded, and crucified in all our sins and indifference*. He is still human, we have said, and can be enthroned in, and integrated with, every human personality by means of the latter's conscious surrender. He is also God. As the perfect man he can enter human life on the human level. As God he has complete union with the Father. He is engaged in an agelong ministry to unify the former with the latter, as we say, "to bring men to God." Space is no barrier now he has laid down his flesh. Every

[45] In the first draft of this book I used the word "identification," but perhaps this fails to express the essential difference between Christ and ourselves, a difference essential for our redemption.

[46] Gal. 2:20.

man in his journey through this world is indwelt by this Divine Being, invaded by this Divine Invader, unless he manages to shut and bar every door of his being against Christ. Even then the Saviour will stand and knock. The battle for God's victory in the human heart may go on till death, through death and out into the unseen, but it is never given up while anything of personality remains that can be "saved." No one can be won without his free will consenting. That consent may be postponed or even refused. No one can guess the cost to Christ of this further imprisonment of his divine being, of this endless agony of prayer and desire and struggle. But thus, and only thus, is the salvation of the world achieved.

We said earlier that no one can bear another's sins in the sense of carrying his burden, or paying his debts, or suffering physically in a way regarded as the equivalent of pain to the enormity of sin. But

If to bear sins means to go where the sinner is, and refuse either to leave him or to compromise with him; to love a shameful being, and therefore to be pierced by his shame; to devote oneself utterly to his recovery, and follow him with ceaseless ministries, knowing that he cannot be recovered without his consent, and that his consent may be indefinitely withheld—if this is to bear sin,

then this is what Jesus is doing still.

We see the meaning of the Cross when we see it as the act and deed of Christ, done with all his heart and mind and soul and strength, when, for love's sake, he burdened himself with the whole situation which our sin had created, *embraced the prospect of endless sacrifice*, and dedicated himself without

reserve, in face of all that sin could make of us, to the task of our recovery to God and all goodness.[47]

In the light of this august truth I can realize a little the meaning of some of the significant experiences of Paul and his language about them. "Who art thou, Lord?" Saul cries on the way to Damascus. "I am Jesus whom thou persecutest," is the reply.[48] Note the simple human name "Jesus," to emphasize our Lord's continued humanity. So it is Jesus who is *still* wounded in that which wounds his friends, indwelling both the persecuted who loves him and the persecutor who does not, but who afterward cries, "Christ liveth in me." [49] So close is the union that Paul speaks of "Christ in you" and of men being "in Christ." "I live; and yet no longer I, but Christ liveth in me." He cannot tell where Paul ends and Christ begins. There is a sense of union, and yet the distinctness of man is always maintained. In one of his letters he uses a most intimate metaphor. To the Galatians he says, "My little children, of whom I am again in travail until Christ be formed in you." [50]

It is almost as if the great apostle cannot find metaphors intimate enough to convey the extent of the union of Christ with humanity that he may redeem and save it from permanent alienation from God. "Him who knew no sin *he made to be sin on our behalf*." "Christ redeemed us from the curse of the law, *having become a curse for us*." [51] What daring and terrible things to say! What do they mean?

[47] Maltby, *op. cit.*, p. 17 (italics mine).
[48] Acts 9:5.
[49] Gal. 2:20. Jesus suffered in Saul even when Saul was enemy of Jesus.
[50] Gal. 4:19.
[51] II Cor. 5:21; Gal.

I imagine two brothers who are twins. Twins often have a strange psychical link between them and are frequently devoted to one another. The prison walls of the flesh, the barriers of temperament and outlook which separate most people, seem to have less power to separate twins. They almost seem to pass in and out of each other's personalities, and sometimes appear to know what is happening to one another even though separated in space. Let me call these twin brothers John and Jim and suppose them to be in their early twenties. Let us imagine John the ideal Christian man, and Jim a man who has done some great wrong—a wrong which reacts cruelly on others, spoiling their lives and frustrating their plans, dragging the family name in the mud, bringing pain and sorrow to many. I think I know what John would do. As soon as possible, he would be at his brother's side. He could not bear his brother's *guilt*, but he would bear more than the measure of his brother's shame. He would do his uttermost in putting right what was wrong. He would be willing so closely to identify himself with his brother that, what with the inward shame and sorrow and the outward hostility shown by others, he would in a real sense bear his brother's sins. He would be "made sin" on his brother's behalf. He would become a curse for his brother. And he would give himself to the task of winning his brother to the ways of righteousness, and know no respite until the task were done. If the phrases about "becoming sin" and "becoming a curse" sound strong, we may recall the way in which a wronged and outraged person rails on the innocent friend of the wrongdoer with words like, "And you too—you're as bad as he is. You're only trying to shield him." In such a picture I think I catch a

glimpse of the cost and manner of our redemption, save for two points which the illustration does not cover.

1. John has only Jim to redeem. Christ is the brother, closer than a twin, of *every human soul*. You say: "But think of the millions in the world—China, Africa, India, America, Europe. Your picture is absurd. It is utterly impossible for Christ to deal personally with everybody who has ever been in the world." Is it? If God created them, can he not redeem them? We are not saying what the human Jesus could do on earth. We are saying what the divine Christ, who is the omnipotent God, is doing in the unseen.[52] He is man still, but also God, and now unimprisoned in space and time. With men it is impossible, but not with God. What other hope has man? Can he ever raise himself by his own shoestrings? Is Jesus Christ the Saviour of *the world*, or not? If he is, how else can the mighty task be done save by dealing with sinners one by one? Granted that as the individual sins he infects others, so the goodness of the individual helps others. If sin is corporate in its effects, so is faith in Christ. Men are a mass as well as units, but an individual response, won by Christ's grace and self-giving, must be made by each individual. It is that same Christ, released from the fleshly limitation, whose love was exhibited in that utter sacrifice, who works *here* and *now* upon *my* stubborn heart, not just on the world en masse. He "ever liveth" for that very purpose. In a sense truer than the author of the book of Proverbs could ever dream,

[52] How revealing is our common phrase, "How *on earth* does he do it?" The phrase is a relevant comment here. On earth Christ could not complete his work. In the unseen it is not only possible but the world's only hope.

134

"there is a friend that sticketh closer than a brother" [53]—
yes, closer than a twin brother.

2. But the illustration breaks down at another point.
John remains outside Jim. However much John loves his
brother, he cannot indwell him. It is significant that even
human love seeks to indwell the beloved. Our embraces
prove that. When your little child hurt himself, you held
him tightly to you. You would like to have indrawn his
whole body within your own, made it an extension of your
own, so that you could bear his pain for him. We clasp our
dear ones tightly to us; and, as said, marriage is as near in-
dwelling another as is possible, for "the twain shall become
one flesh." [54] Note the lovely couplet in Tennyson's *Prin-
cess*:

> So fold thyself, my dearest, thou, and slip,
> Into my bosom *and be lost in me*.

While he was in the flesh, even Christ could not indwell
men, though he identified himself with them so closely
that, in terms of feeling, when he touched the leper he be-
came the leper in everything but physical symptom. But
now he strives with men from within. It almost takes one's
breath away to imagine what this means. I myself, like
every minister who deals hour after hour with souls, be-
come exhausted by hours of interviewing people in trouble.
They pour out their sorrows and sins and worries and diffi-
culties and problems until one can carry no further bur-
dens. But I have defenses. I can refuse to see people. I can
go away from the city. I can neglect to answer their letters.

[53] Prov. 18:24.
[54] Matt. 19:5.

Sheer exhaustion becomes a defense. Breakdown would speedily be the lot of the human who sought to bear the burdens of a vast number of people and who did not sometimes retreat behind defenses. In the days of his flesh even Christ went away for long periods in the hills.

But now Christ has no defenses. He cannot be exhausted, for he is divine; but see how he has given himself utterly into our hands. He has no defense of indifference or carelessness or withdrawal. He cannot cease to love and therefore cannot "refuse to be drawn into it." There are no walls of his flesh to separate him from us, no time barriers which make him "too busy to undertake our case."

Men have written much of the physical sufferings of Christ. And indeed we cannot bear to think of them in detail. But many men have suffered physically more than he. I sometimes think that just as physical pain is often concentrated on, and even produced, by the mind partly to deflect the latter from mental anguish,[55] so we concentrate on his physical sufferings that we may not be asked to contemplate that which—fully comprehended—would unhinge the mind, namely, the agony of God in Christ.

Let us, however, receive, as far as we can, the thought of this continued passion and ministry which the indwelling Christ carries on. Sometimes on some errand of love I go to the slums or some foul den of thieves or some haunt of evil. I pity. I sympathize. I try to help. Then I come home. I bathe. I eat. I sleep. *But he stays there*. He is still in that foul den, that slum, that brothel. Or, if my work takes me elsewhere, still he is in that quarrelsome home, that fearstricken heart, that churchman's insolent, proud little soul.

[55] As in the case of some hysterical and functional illnesses.

He, my Lord, is still crucified there—still trying to rise again, still guarding that last strip of territory in a personality seemingly captured by the enemy, still tending that spark underneath the ashes when to my view the fire is wholly extinguished, still holding up the reed when it is broken and crushed and has no human strength left in it:

> Softly he touches, for the reed is slender;
> Wisely enkindles, for the flame is low.

How well I remember visiting a leper settlement in India, speaking to the lepers, spending the day with them; and then—having sympathized and done any small thing or said any small word to help—I went to my bungalow, bathed, changed my clothes, and sat down to dinner. *But he, my Lord, stayed there,* imprisoned within the being of pagan, ignorant, incurable lepers.

And when Christ saw the adulteress—if you can bear it —he became an adulteress. Not the one who commits sin. Guilt cannot be transferred. But one who knows the shame of it all, the self-loathing that follows—knows it better than the sinner, for purity knows more of the nature of sin than sin knows. Sin blinds the eyes of the sinner to the nature of his own sin.

"Christ in you, the hope of glory," says Paul.[56] And when I think of Paul himself it sounds true—Christ expressing himself through that magnificent courage, that indomitable spirit, that tireless energy, that eloquent voice, that amazing brain. But the other night I saw, in the nameless quarter of a sordid little town, an old man in rags, with red, syphilitic eyes, go reeling down the street on God

[56] Col. 1:27.

knows what errand, and in my heart I said: "Christ in him, the hope of glory"—the only hope, for he has no will, no decency, no pure desire of his own left.[57] I thought of John Masefield's lines which, in "The Everlasting Mercy," he puts into the mouth of the little Quakeress:

> "Saul Kane," she said, "when next you drink,
> Do me the gentleness to think
> That every drop of drink accursed
> Makes Christ within you die of thirst,
> That every dirty word you say
> Is one more flint upon His way,
> Another thorn about His head,
> Another mock by where He tread,
> Another nail, another cross,
> All that you are is that Christ's loss." [58]

So our Redeemer, walking the long Via Dolorosa of humanity's sin and shame, goes on his way. What he bears we may not know, we cannot tell. No wonder there is joy in the presence of the angels of God over one sinner that repenteth, for every repentance, as it were, draws out a thorn from his brow, a nail from his hands and feet, as well as winning for the sinner himself a joy unspeakable. We rejoice that Christ proceeds victoriously. There are more people who love him and follow him than ever there were in the world before. But how dreadful his burden, how steep his path! Only God could bear that. No human Jesus, however perfect, could accomplish this. The human Jesus could give us an example and die a noble death for a great

[57] The last three paragraphs are repeated with minor changes from an earlier book, *Discipleship*, pp. 143-45.

[58] From *Poems*. Used by permission of the publisher, The Macmillan Co.

cause. But only God the Son could do this mighty thing for us. Behold the Lamb of God who gradually taketh away the sins of the world, by his union with every sinner who will receive him.

And our only hope lies in that he has done it, is doing it, will do it, until all the sons of men become the sons of God, save those, if any there should be, who finally reject him. It is a platitude at a time like this to say that humanism—the glib doctrine that man needs only his own unaided human powers to realize all his possibilities—has failed. Man has no hope left. His bravest plans, his brilliant theories, his scientific discoveries and inventions, his philanthropic enterprises have not brought Utopia. He shudders at a hell unloosed around him more horrible than the pre-Christian era could possibly have dreamed. The very gifts of God to man, misused, have brought us a greater hell than ever the cave man could know.

What greater hell—probably ending life altogether on earth—would descend if Christ did not continue to "save the world" we may not even imagine. "There is a tradition that, when the fortunes of the Federal States were at their lowest in the American Civil War, and Lincoln was the target for all manner of calumny, rancor and abuse, a friend said to him: 'Why not resign and let them sink or swim?' To which Lincoln slowly and sadly replied: 'If I resign they perish.' " [59] If Jesus Christ resigned, the world would be like a lovely garden whose owner left it to the weeds. Rank growths would soon choke the flowers, and a wilderness would replace beauty. So, in the world, selfishness and evil would spread, and moral degradation bring desolation,

[59] Quoted by permission from Alex. McCrea, *op. cit.*, p. 275.

decay, and the death of the fairest blooms of the spirit. But oh, my soul, lift up thine heart, for thy salvation draweth nigh. Jesus will not resign.

> Ah, no! thou life of the heart,
> Never shalt thou depart!
> Not till the leaven of God
> Shall lighten each human clod;
> Not till the world shall climb
> To thy height serene, sublime,
> Shall the Christ who enters our door
> Pass to return no more.[60]

Man is not deserted by God, or he would go down in a convulsion of evil that would reduce the whole world to a chaos and leave only a few gibbering idiots to wander over the ruins. This "discreditable incident on a minor planet" which we call history would be over. No! On this wayside world has been enacted a play which angels must watch with amazement. The God of this unknown, terrifying universe trod this earth as man; and though his body was murdered, still as the Man-God he ministers to human nature, never leaving nor forsaking it, never forswearing his kinship with it, wrestling and struggling within it until it is redeemed and becomes what God meant it to be. By Christ's union with man his holy nature seeps through our foulness, cleanses and restores it. This is what John meant by this word: "The blood of Jesus his Son [the very nature of Christ] cleanseth us from all sin." [61] Thus and only thus are men saved, and to be saved means to be delivered from

[60] Richard Watson Gilder, "The Passing Christ." Used by permission of Houghton Mifflin Co.
[61] I John 1:7.

that final separation from God which the New Testament calls death, and which may involve such deterioration that man ceases to be a personality at all. In eternity, where time is not, the great redemption is achieved already. We, poor victims of the time prison, say, "It continues," and that "it will go on." Words fail us here. But he has spoken in a deed. He has saved the world, is saving it, will save it, whichever word you choose. But there is no denying the deed. A Cross was raised up on a hill outside an ancient city. On that Cross was one who was both man and God. What God was once, he is now and forever. His reaction to sin once is his reaction to sin always. The reaction of Jesus to sin in A.D. 29 is the reaction of God to my sin today. He is hindered, wounded, limited by it. But that suffering love is not the exhibitionism of a martyr, or an attempt to win me through pity. It is the self-giving of God in a love which is my only hope of being changed until I am all that he can make me, a being in a unity with him closer than any words can describe, a being through whom he can work unhampered in his redeeming task. That Cross was an event in history. But it is the translation into terms of history of an eternal fact. It was a deed done in time. But it was a deed of eternal significance, a promise and a pledge of endless loving backed by the very nature of God. In that deed the mind finds rest. At the foot of the Cross the troubled, stricken heart finds peace at last.

CHAPTER VII

The Manner of Our Deliverance

"Justified by Faith"

WE SAID earlier that guilt is not transferable and that no satisfactory theory of the Cross can be established by pretending that this is otherwise. We saw in the last chapter how closely Christ comes to us—closer than a brother, dwelling within us, sharing our shame, and, in the sense explained, bearing our sins, winning us to a new way of life, and creating in us a new nature. To indicate that closeness we even used the word "union," guarding meanwhile the separateness and distinction between Christ and our sin-drenched lives.

But if guilt is never transferable, if it can never be true to think of Christ as guilty—and this view I hold—does guilt live on forever? Does the sinner carry this awful load through all eternity? If so, it is difficult to escape the conclusion that all who have passed over live in mental torment. For memory persists after death,[1] and as one increases in spiritual insight, the awfulness of one's past sins must surely become a burden insupportable. As one increasingly realizes what sin has cost a loving God, then surely one's sense of guilt deepens.

[1] Cf. the parable of Dives and Lazarus—"Son, remember." (Luke 16:19-31.)

As I read the Pauline epistles, it seems to me that it was to meet this formidable problem that Paul worked out the theory of justification by faith. The title of the doctrine puts the plain man off, but he must not miss this glorious truth. It was the center of Paul's missionary message. Let us try to take in the meaning of that last sentence. The first message of Christianity—and the epistles were written before the Gospels—was no anemic demand to be "like Jesus" based on stories of his life. It was that his death and resurrection had opened up a new way by which sinning man could become one with a holy God because his sins and their guilt had been dealt with. He was forgiven and *justified*.[2]

To be justified means to be *known* to be guilty, but to be *treated* as righteous. The plain man puts his tongue in his cheek at once, and regards this as a verbal wangle illustrating the way theologians waste their time. But the doctrine, set forth so powerfully in the Epistle to the Romans, and elsewhere in Paul's other letters, was written down by a missionary on tour and addressed to an infant Christian community. Within the law courts the idea is of course absurd. But a moment's thought shows that within the ideal family it is gloriously true. If a son has sinned against his father and is penitent and forgiven, the ideal father does not treat him any differently from the way in which he treats his other sons. The boy goes about with his father. He is introduced to his father's friends. No reference is made to his sin. No cloud spoils the relationship. The boy is continuously treated thereafter as though nothing

[2] "In Christ Jesus ye that once were far off are made nigh in the blood of Christ. . . . For through him we . . . have our access . . . unto the Father." (Eph. 2:13, 18.)

had ever broken that relationship. Any other treatment would hinder his progressive attainment of "righteousness" and be a permanent barrier between the boy and his father and other brothers. The boy is "justified." He is *known* to be guilty. Nothing can ever change that. And the effects of his guilt in many ways remain. Some, indeed, may be physical. But he is *treated* as if he were innocent. The *love* of the members of his family achieves this—often at great cost.

I heard of a churchgoing woman whose maid "sinned" in giving birth to a child outside marriage. The woman "forgave" the maid, but even years afterward rebuked the maid for some trifling fault, and said to her, "You are not nearly grateful enough to me, Ethel; it isn't every woman who would take a 'fallen' girl into her home." Ethel should not only have been forgiven, but treated as righteous. The employer should have extended to her maid a belief in the latter's recovered or recoverable righteousness. The mistress should have tried to hold in mind a picture of Ethel, not as a sinner and so-called "fallen" woman, but as created anew by the power of forgiving love. That is what Christ does for us. And Ethel's belief that this had been done would have been the most powerful agent of recovery. It is hard for a human being to do this for another, partly because of the separation of the two lives and partly because every human being is himself a sinner.

But that is justification. Wesley identifies it with forgiveness, but forgiveness, it seems to me, is an act restoring the relationship but leaving the sense of guilt unremoved. Justification is a process which gradually disperses the sense of guilt by continuously treating the sinner as guiltless.

Then the sense of guilt disintegrates and sloughs away, leaving only a scar. And although our wounds are self-inflicted by our sins, and unlike Christ's, which evil from without inflicted on him, yet by his mercy and grace we too may have "glorious scars" [3]—scars that remind us and others more of his loving patience and endless grace than they do of our own sin.

If, then, we receive the Christ who is willing to identify himself with us—which requires faith—and so surrender ourselves continually to him that his holiness can seep through our infected nature and cleanse it, like some healing antiseptic through infected tissue, we are not only cleansed, but brought to such a state that God can regard us as guiltless. He sees us in the light of what we are becoming, of what Christ is making us, of what we are "in Christ"; and, in the eternal world where time is not, he equates our future with the present. "In Christ" we can be treated as righteous already, since, unless we break from Christ, that is what we shall become.[4] Faith in Christ, faith that we are vitally linked with him and that he is doing all this within us, is essential. We are justified by faith, a faith which hands the old self entirely over to Christ, that through trust and obedience, which together constitute faith, the new man may be born by his grace and power. In

[3] Cf. Charles Wesley:
> The dear tokens of his passion
> Still his dazzling body bears;
> Cause of endless exultation
> To his ransomed worshipers:
> With what rapture
> Gaze we on those glorious scars!

[4] "In Christ God reconciled the world to himself *instead of counting men's trespasses against them*." (II Cor. 5:19 [Moffatt].)

Dr. Moffatt's simple and direct translation, "A man is justified simply by faith in Jesus Christ." [5] *Christ's union with us is so close that God cannot regard us in any other way than that in which he regards Christ, the dearly beloved Son.*

I am aware that, to make this clear, I am separating God and Christ, but it is inevitable in order to make the point, and a certain separation is factual if, as I believe, Christ is still human. We are *in Christ Jesus* and one with him, and thus God will regard us. Nothing could be clearer, I think, than the fact that this union with Christ is the very center of Paul's missionary message: "He who joins himself to the Lord is one with him in spirit." [6] The condemnation which, in a moral universe, would otherwise be essentially associated with guilt, breaks down. Effects of sin remain, but their nature is changed. No longer are they the soulless retribution of a moral order, but the friendly discipline of a Father, and a discipline to be welcomed because it makes us what he wants us to be. But, let it be repeated, condemnation is gone. "There is therefore now *no condemnation* to them that are *in Christ Jesus*." [7] The union with Christ is regarded as having done that which it assuredly will do, make us like him. [8] We have yet to become, but *potentially* we are already Christlike, sons of God, joint heirs with Christ, and are thus treated.

[5] Gal. 2:16 (Moffatt).
[6] I Cor. 6:17 (Moffatt).
[7] Rom. 8:1.
[8] If the earliest Christian message can be put into two or three words, here they are: "In Christ," or, "In Christ Jesus." I read through Paul's epistles underlining in red the times he uses the phrase. The result moved me profoundly. In Ephesians it is used five times in the first seven verses!

Nowhere is the message more gloriously expressed than in Charles Wesley's hymn:

> No condemnation now I dread,
> Jesus, with all in him, is mine;
> Alive in him, my living Head,
> And clothed in righteousness divine,
> Bold I approach the eternal throne,
> And claim the crown, through Christ my own.

The idea of little insect-man, the polluted sinner, ever contemplating an approach to an all-holy, infinite God, the Creator of this vast universe, would be ridiculous; but, as it were, tightly holding the hand of Christ, being "in Christ," as Paul loved to say, man can even approach with boldness, for Christ's union—let it be repeated with all possible emphasis—means *God does not regard the sinner in any other way than he regards his own dear Son in whom he is well pleased.* God cannot "turn down" the sinner who is "in Christ" or he would be turning down his own Son. The two are one and inseparable. As a friend said to me, "Christ's closeness to the sinner who trusts him reminds one of the phrase, 'They are wrapped up in each other.'"

I am writing these words in a lovely garden under a cedar tree, on a perfect day in early summer. The air is sweet with the scent of the cedar and of a lilac tree in full bloom. A chaffinch is singing a rhapsody above my head. At my feet is a dog, Pete, aged and feeble. He is a dog without much to commend him as far as appearances go. For some time his back was red-raw with disease, and his destruction was contemplated. Indeed, one veterinary surgeon recommended that he should be "put away." He is the property

of Mike, the only son of my host and hostess. Mike had to interrupt a university course to serve with the forces. He is in the navy. Knowing my host and hostess well, I could, without rudeness, make a comment, not too complimentary, about Pete. Although now he has fully recovered, he totters about the garden. He cannot run. He is not in any pain and appears to be happy, but no one would claim that he is either useful or ornamental. My hostess explained that Peter certainly was a great care and something of an anxiety; but, she added, her eyes softening, "We love him *for Mike's sake.*" They saw the dog as something Mike loved. They couldn't have done away with the dog because the dog was bound up with Mike and Mike with the dog. They would hardly like to meet Mike's eyes after the war if he said, "Where's Pete?" and they could only answer that he had been "put away" because he was a nuisance and no use and not worth saving.

I think of that incident sometimes, when, at the end of prayer, we ask God to hear us and receive us "for Jesus Christ's sake." We are not much good either—from one point of view, a nuisance in the universe, the only things in it that bring disharmony. Guilty sinners we all are, and wholly unfit for God's holy presence and care, but guilt disintegrates when we are treated for Christ's sake as if it didn't exist, because he loved us and gave himself for us. We need not even wait until we are wholly cleansed of sin. We can come now. This Man who is God receiveth sinners, dirty old dogs fit only to be destroyed; and when, in despair and penitence, they cast themselves upon him, trusting him to do what they cannot do for themselves, and save them, not from *all* the effects of sin, for some effects

do useful disciplinary work by persisting, but from sin's continuance and from those effects which would certainly mean deterioration of character and separation from God, then he unites them to his Father by his unceasing ministry for them and union with them.

> Look, Father, look on his anointed face,
> *And only look on us as found in him.*
> .
> For lo, between our sins and their reward
> We set the passion of thy Son our Lord.

And when we speak of his passion, we mean not just his physical death, but the endless self-giving in love of which the Cross is both symbol and pledge. So, in Paul's daring phrase, God "justifieth the ungodly" as having real worth in themselves *because* they are linked with his Son. Instead of the burden of eternal guilt which would make man increasingly miserable and remorseful, as he perceived its awful nature, the new man in Christ is given back his self-respect. What is so important psychologically for his recovery is that, instead of picturing himself as one morally beaten, weak, and worthless, *he sees himself in Christ* cleansed and strong and renewed and whole and, as long as he remains "in Christ," unconquerable. And what shall separate him from the love of Christ . . . ? Nothing can, unless he will have it so. Further, he no longer regards himself as worthless, since Christ thinks him worth loving and worth dying for.

I would like the reader to turn back, if he will, to the illustration of John and Jim. [9] John, we remember, was of

[9] Pp. 133ff.

fine character, Jim the opposite. When trouble fell for Jim, we imagined John going at once to Jim, standing by him through thick and thin, meeting the abuse and scorn which Jim's conduct evoked, feeling the shame of it all even more than Jim did, *but seeing his twin brother through*.

Now imagine the two returning to their father, whom, we will suppose, is ideal in character. John has his arm around Jim's shoulders. Recall, if you will, what was said about a human embrace, how it is a symbol of a desire for identification, to draw the loved one within one's own nature and suffer for him in one's own being. There is no weak excusing of wrong done, no pretence, no shame. But the father, whose nature, let us for the illustration's sake imagine, is perfectly shared by John, knows that John will stand by Jim and never leave him, that the twins are one in a union for which we haven't the right word, and that, while nothing can ever lessen the father's hostility to evil which has wrought such harm in Jim and through him to others, he not only loves Jim, but can receive him and *treat him as innocent* (= justification), for he and John are one.

To interpret the parable: that deterioration of character which is the real punishment of sin ceases, and the havoc wrought by sin in the soul is progressively overcome, leading ultimately to Christlikeness, as long as the sinner and Christ are the inseparables which Christ's loving and costly brotherliness makes possible. Christ, for the sinner's sake, has forsaken his equality with God, accepted imprisonment in the flesh, willingly allowed that flesh to be tortured on the cross and his blood to be shed, and all as a symbol of a yet greater sacrifice. Christ has betrothed himself to the sinner, retained his humanity, and sworn never to leave

him, and will, if the sinner trusts him, identify himself with him and achieve man's highest goal and blessedness, namely his union and at-one-ment with God the Father. That is what our fathers called the "Plan of Salvation." The sinner must have faith enough to be held by Christ and to surrender to the forces which are changing him. Then his burden of guilt will disintegrate and vanish, as Christian's did in Bunyan's allegory.[10] He will be saved from separation from Christ and the Father which his sins would otherwise have made inevitable. Such separation from God leaving the soul to itself spells "death" and "hell." As he clings to Christ, however, by faith, that faith is "reckoned for righteousness," [11] for, because of it, the sinner is potentially righteous already.

Many plain men think all this is imaginative nonsense. "Surely," they say, "if a man wants to be a good man, he can do it himself. Why does he need religion and all this talk of a Saviour? He has ideals and a will of his own." Without disparaging that moral effort which is demanded from all of us, however, what we forget is that because God is God, and perfect, his demand on us is for perfection, and not only a sterile correctness of behavior but a loving relationship with himself. It is a demand we cannot fulfill.

> Not the labors of my hands
> Can fulfill thy law's demands.
> Could my tears forever flow,

[10] "So I saw in my dream, that just as Christian came up with the cross, his burden loosed from off his shoulders, and fell from off his back, and began to tumble, and so continued to do till it came to the mouth of the sepulchre, where it fell in, *and I saw it no more.*"

[11] Rom. 4:5.

Could my zeal no languor know,
All for sin could not atone;
Thou must save, and thou alone.

Seeing what is demanded and failing to reach it, man falls into despair, trying hopelessly to carry a growing burden of piled-up guilt through failure. The conflict between what we should be and what we are able to perform is acute indeed. God demands righteousness, and man cannot make himself righteous, nor is an imposed righteousness of moral worth. It is a fiction. The only solution is that a timeless God should receive *now* as already righteous the man who, because he is "in Christ," is already in process of becoming like him.

It is sentimental nonsense to suppose that a man can continually "enjoy" evil and continually be in communion with God. Before he can know and love God, he must either cease to be a sinner or come as a penitent sinner to Christ and find God *in Christ*, through Christ's self-giving and identification. Only thus can a sinner *stand right* with God. That "standing right" is what theologians call justification. No man can achieve it. God will give it to those who believe and who in penitence trust him. This is the whole aim of Christ's postresurrection ministry—"He was raised for our justification." [12]

If this is too difficult, take refuge in the human picture. Christ's arm is round us, and he presents us to God as one with himself. We are only "acceptable in the Beloved." We are received for his sake. We must trust him to do a Saviour's work. We have to co-operate, but he must do

[12] Rom. 4:25.

the saving both from sin and from despair. A mind finds rest when it is believed that what God demands and what man, at his best, longs for, but finds beyond him, God in Christ will growingly perform. Nor when we speak of man's potential "righteousness" are we misusing words. There is a righteousness of becoming as well as of full achievement. A rosebud can be beautiful, even perfect, before it is the complete rose; and a man who has not even glimpsed the fullness of all he can be "in Christ" can find a beauty of life at each stage of his progress, at each step of Christ's work within him. There is an interim righteousness. And Christ is the pledge of man's final perfection.

I have called justification a process. I should have said of it what R. C. Moberly says of forgiveness, which, differing from Moberly, I should have described as an instantaneous act following penitence and readiness to forgive others. "Earthly forgiveness," he says—"real in the present, but real as inchoate and provisional—only reaches its final and perfect consummation then, when the forgiven penitent . . . has become at last personally and completely righteous. It is not consummated perfectly till the culprit *is* righteous."[13] This I should have called justification, a much richer experience than the initial act of forgiveness which precedes it.

Forgiveness to me is the gate which lets me into God's garden. Without that thrown open to me I am barred from God. But once inside I find a long drive leading up from the gate to the throne room. Even though forgiven, I am nervous. I know I am not fit to approach a holy God. But there is Someone with me—Someone who opened the gate.

[13] *Atonement and Personality*, pp. 48-73.

> There was none other good enough.
>> To pay the price of sin;
> He only could unlock the gate
>> Of heaven and let us in.

That Someone goes with me up the drive, his arm across my shoulders, giving me courage, identifying himself with me. Justification is the process of walking up the drive with an increasing experience of my utter one-ness with the friend who sticketh closer than a brother. "No condemnation now I dread." I can even face God. He will receive me for Jesus' sake, even though I am a sinner.[14]

> Then will he own my worthless name [15]
>> Before his Father's face,
> And in the new Jerusalem
>> Appoint my soul a place.

But, thank God, I need not wait for the new Jerusalem. This very day, this very moment, I can be forgiven, justified, saved. But I must have faith. Justification is by faith.

One last word about faith. How can I get this faith? I puzzled long about this. And then, most illuminatingly to me—familiar, no doubt, to many who read this—came the thought that everybody already has faith. It is God's gift, and he has given it to every man. It may be faith in the wrong things or the wrong people. But even he who asserts that he needs no faith and will walk only by sight has faith

[14] As Charles Wesley sang:

>> That sinner am I
>> Who on Jesus rely
> And come for the pardon God cannot deny.

[15] "Worthless" of and in itself; made worthy only through the love of Christ.

that faith is unnecessary. Many *feel* they have no faith, but for some reason or another it is only that the feeling part of their psychological apparatus is out of order. Mental depression, for example, can kill the *feeling* of faith, but faith will return as the depression passes, as pass it surely will.

Let's attach the faith we have, however small, to Christ, abandoning that clinging to self and human security which makes us try to dispense with faith in another. Let's take him at his word and act on the assumption that he would not make promises he could not keep. If he says he is with us, he is. If he says we are to trust him, he is trustworthy and won't let us down. If he says he will save us, he will if we co-operate. The power which spread the gospel Paul preached is not cut off. The early church was not based on an illusion, or the faith of the saints on a lie. We may only be able, with one of old, to say, "I believe; help thou mine unbelief." [16] He won't despise that lowly offering of faith, but use it to make us an overwhelming return on our investment. For faith the size of a grain of mustard seed he prophesied a result to be measured in terms of mountains. [17] Let us, with what faith we can muster, throw ourselves on his grace.

"Saved by His Precious Blood"

How familiar are the words which form the title of this final section. Yet in spite of their familiarity—or perhaps because of it—they are little understood. To some, indeed, they are an offense. "Saved"—the word suggests those burglars of our souls who sometimes, with more zeal than tact,

[16] Mark 9:24.
[17] Matt. 17:20.

ask us at awkward and embarrassing moments that most intimate of all questions: "Brother, are you saved?" "Blood" —the word suggests those rather revolting hymns that express a crude evangelism which nice, respectable, educated people like ourselves resent!

Just so! But if, because we scorn old-fashioned phrases, we miss the truth behind them, then our loss is indeed grievous. Many young people today are suffering such loss. I was like them myself not so very long ago. A species of mental pride, a scorn of old phraseology, an inertia that will not trouble to ask what is meant, a subconscious desire to hide from the thrust of truth, either under the excuse of not understanding, or behind figures of speech which repel, or perhaps all these added together, combine to prevent needy people from feeling the necessity of a personal Saviour and from entering that blessed experience which he has made possible by his death and resurrection, and which our fathers called salvation.

Such a loss is grievous indeed, for the heart of the gospel is the saving power of Jesus Christ. No anemic, watered-down presentation of Christ as Hero, Influence, Example, or even Friend, is a satisfactory substitute for that rich, full-blooded gospel of salvation. It is sufficient evidence of this to mark the character of the message with which the first apostles confronted a pagan world: "We preach Christ crucified"; "God commendeth his own love toward us, in that, while we were yet sinners, Christ died for us"; "Believe on the Lord Jesus, and thou shalt be saved"; "The blood of Jesus his Son cleanseth us from all sin." [18] "Saved"—"blood"—we cannot by-pass the great

[18] I Cor. 1:23; Rom. 5:8; Acts 16:31; I John 1:7.

words without emasculating the New Testament message. It is reported that a few hours before his death John Wesley said, "in a low but very distinct manner, 'There is no way into the holiest but by the blood of Jesus.'"

Let us look at the words.

"Saved." Well, the word is simple enough! Saved from what? From hell? "Surely," says the plain man, "you are not going to ask us to revive the doctrine of hell. That is outmoded, and no one believes in it." Well, I do for one. The question as to what its nature is, and whether it is endless, I have discussed elsewhere; [19] but, modern or not, I cannot dismiss the idea of hell without making nonsense of the New Testament.

Hell is a state of mind. It is not a punishment inflicted so much as the inevitable effect within a moral universe of moral causes. If a man, by not considering where or how he is walking, walks over the edge of a cliff, we do not say his fall is a punishment. Why is it any more a "punishment" when one brings suffering upon oneself through not looking where one is going spiritually? If a man tries to live without food or air, we don't talk of his death as a punishment but as a consequence. If he tries to live without God, he finds it easier to do so for the simple reason that instincts press him to attend to food and air, whereas it is evidence of God's respect for human freedom that the yet more important matter of the necessity of God is not brought to consciousness by instinctive mechanisms. God wants us to want him for his own sake, not because we are driven to him by instincts. But God is as much a necessity to the life of the soul as food is to the body. Omit food and the

[19] See *After Death*, pp. 67 ff.; and *In Quest of a Kingdom*, pp. 242 ff.

body dies. Omit God and the soul dies. The pangs of hunger are beneficently designed to save the body. Hell is a beneficently designed experience through which a soul in danger of dying passes so as to save it from extinction. Browning calls it

> . . . that sad obscure sequestered state
> Where God unmakes but to remake the soul
> He else made first in vain; which must not be.[20]

But hell is no more a punishment than starvation. It is not endless, or it could not achieve that for which it is designed. Incidentally, though we cannot escape using words which connote time, no word doing so can represent reality in a timeless world. Hell is a consequence. The laws of a physical universe relentlessly operate. It is the effect of law in a spiritual universe. Law runs through the whole universe and cannot be defied without consequence either in the physical or in the moral realm, though in the latter effect often follows cause only after a lapse of time—perhaps, indeed, the effect is not noticed in this life at all.

Hell is the anguish of self-discovery as the soul contemplates the horror of sin and the separation from God which satisfaction with a sinful life has effected—an anguish made worse by an unwillingness or inability, even then, to turn to God, coupled with an utter despair of being able to change oneself. Hell and despair are almost synonymous terms. Christ deals with this despair and saves from hell. The penalty of sin is not, I think, fully understood in terms of physical or mental suffering, though both may be part of it and bitter indeed.[21] (It is dangerous to generalize here,

[20] *The Ring and the Book*, "The Pope."
[21] Cf. our Lord's words, "Sin no more, lest *a worse thing* befall thee." (John 5:14.)

for physical and mental suffering occur without being caused by individual sin, and sin often appears to be done without the sinner's suffering any obvious result *in this life*.) The worst penalty of sin is that man is separated from God, his spiritual senses dulled, his spiritual desires lessened. Such separation involves *progressive deterioration of character*, which, if unstayed, may indeed involve such a disintegration of personality that the latter ceases to be recognizable as such, and possibly falls back into the pool of being from which it was formed by the fact of birth. We reach here the realm of speculation as to the manner of the soul's death, but the fact cannot be dismissed, for both our Lord and his greatest apostle use the word "dead" or "death" to describe the doom of the unredeemed soul.

If sin is at work in us, separating us from God, hindering his work, causing Christ anguish, and distintegrating our own character, then blessed, yes, blessed be the pain of self-discovery—however searing and hard to bear—which makes us see the dread end of the road we are treading and call out, though it be in the anguish of despair, "What must I do to be saved?" [22] I know this sounds a grim doctrine. But he is no friend of mine who minimizes the result of my sins, who teaches an "all-will-come-right-in-the-end-for-all-men" doctrine. It was no light matter that sent Christ to the Cross. It was no trifle that made Christ use words like

[22] Acts 16:30. It always seems to me unlikely that the Philippian jailer would think of his soul at such a moment, wakened as he was by an earthquake at dead of night. The escape of the prisoners meant the death of the jailer's body, and it is unlikely that he was thinking of his soul. I think Paul characteristically used the situation to point out the greater need of the jailer and to offer the remedy.

"dead and "lost"—"This my son was *dead*, and is alive again; he was *lost*, and is found." [23] After all, the doctrine of hell, exaggerated to a caricature by our grandfathers, derives from the words of Jesus. It was he—who loved and was kindhearted beyond all others—who used the words "outer darkness," "the door was shut," "the agelong fire"; [24] and it was the greatest of the apostles, Paul, who remained to the end conscious of the possibility that "after that I have preached to others, I myself should be rejected," and who wrote, "The wages of sin is death," and, "Whatsoever a man soweth, that shall he also reap." [25]

If I could write more lightly about sin, I would do so, for its results terrify me. But I cannot escape from the view that sin—including the negative sins of sloth, indifference, doing nothing about the needs of men, and the kind of selfish pride which, in an isolated and cushioned life, may not seem to do any definite harm—does, if long continued in, especially if accompanied by wealth or success or both, lead to a condition for which we have to use terms as severe as those of our Lord and of Paul and John. What right, indeed, have we to water down the stern gospel message? What presumption it is if we dare to soften the words of the Master in the name of kindliness! Was he, then, not the kindest of all the sons of men? Are we to say to men: "Sin doesn't really matter much. Christ's language was too severe. God will pat you on the back and say, 'There! There! You didn't mean it. It doesn't matter.' "? No! that won't do. And in modern religion we must re-

[23] Luke 15:24.
[24] Matt. 8:12; 25:10; 18:8; cf. Matt. 25:41; Mark 9:44; etc.
[25] I Cor. 9:27; Rom. 6:23; Gal. 6:7.

cover the stern note of the New Testament. Jesus has rightly been called gentle. He remains forever the friend of sinners, but against sin he hurled an invective more terrible than any other before or since. He hated it with implacable hatred and fought it to the death. He knew it for what it is—the greatest enemy of man, the most dangerous thing in the world.

There is an urgency about the true gospel message which I would fain recover, and which cries out to men to heed and to repent and to trust and to seek a seeking Saviour, since the road on which they travel in sin will bring them to inevitable and bitter suffering, and finally, perhaps, to nothingness and the second death.

Well, for myself, I want to be saved from that, partly from a motive of fear, for fear is a "tutor to bring us unto Christ," [26] and partly through a vision of beauty. I've caught glimpses of reality in the life of Jesus and of the saints, in all goodness, in truth, and, for me especially, in beauty—the beauty God makes in his world and the beauty he allows man to capture in music, art, and poetry and in the love of friends—I see there what life *might* be, and I want it desperately. At my best I hate the ugliness and unhappiness that sin brings into my own life and into the lives of others, and that it brings into life everywhere when, without it, all might be harmony and beauty.

It isn't that one demands happiness. In Christ we find something deeper than happiness. The word "happiness" always seems to me to belong to the surface of life. Many people are "happy" only because they have never examined themselves, never understood what life means and what

[26] Gal. 3:24.

God is like, never felt the heartbreak of the world and the burden of other people's sorrows, never seen the Cross at the heart of the world's beauty even as it is in the center of a passionflower. We are not here to be happy. We are here to develop a personality capable of communion with God and, as we do it, to pass on the secret to others. We cannot do it alone. The secret is living "in Christ." No one can ever do another a greater service than to "bring him to Christ."

Few people who know themselves are happy. How can anyone be happy who has found himself out, and who realizes the difference between what ought to be and what is? Yet the misery of self-discovery *can* be followed by giving up oneself entirely into the hands of the only one who can deal with our desperate plight. And in that surrender, while there may be little happiness, there is joy. How can anyone be happy who sees Christ put to death every day by the sin of man? Yet that vision may lead to dedicated service which brings something much deeper than happiness—joy. And that, not happiness, is what he offered—"that my joy may be in you, and that your joy may be fulfilled." [27] Many a pagan is happy, but it is the fool's paradise of the blind. In passing, one might say that psychoanalysis always makes people unhappy for a time. What is essential is a subsequent psychosynthesis, a new orientation. That I hold to be incomplete without Christ, and to find the Christian synthesis is to be saved. Analysis shows up the personality with all its failings, and the points at which wrong turnings were taken, and, to change the figure, how a faulty character pattern developed; but in

[27] John 15:11.

Christ and his gospel is an answer to every failing and need. As these needs are met, a new integration is arrived at and the personality made whole. But of course this integration is effected for thousands who have never heard of psychoanalysis. In most cases true conversion is all that is necessary. *But no conventional sham is any use.*

How, then, may we be saved? By yielding to Christ, here and now, holding nothing conscious or semiconscious back, and trusting him, who has committed himself to us, so to identify himself with us that, as he has himself promised, we shall be brought at last, holy and without spot, to fulfill God's purpose in allowing our creation. To be saved does not mean to be brought at once to perfection. Obviously that will take time and most of eternity. It does mean that the process can begin now. We are not at the end of our journey, but we are on the road that leads to journey's end. It is not a matter of something done but of something begun. To the crude question, "Are you saved?" I can give a triumphant "Yes," for I have found in him the road that will lead me home at last. I stray off the road again and again, get into the wilderness tangle on the roadside, follow the devices and desires of my own heart, and do so to my own hurt and his heartbreak. But the Good Shepherd is mine, now, and I am his, and I know his voice, and I know that what my best self craves is to be found with his flock, on his road, following his way; and, otherwise hopelessly "lost," [28] I get back to the road of heart's desire which all

[28] I do not think the New Testament use of the word "lost" implies one whose destiny is sealed in an inescapable hell, in the sense in which we speak of " a lost soul." I think it means "lost" in the sense in which a child is lost in a wood. He does not perceive and follow the road that will lead him home.

the "saved" tread. These are the elect, *and anyone may join them*, for "whosoever will may come."

The remainder are lost, at any rate for the present. They may be the damned—namely, those who, even after the self awakens, themselves choose the way of death. There can be no valid or convincing judgment which the awakened soul does not pass on itself. But I dare not mince matters. To see the best and know it *is* best and to persist in the doing of the worst—a doing which always affects other lives—inevitably, by the law of cause and effect, brings the soul to the kind of hell I have described. To spurn the Saviour who holds out the only hope of blessedness, and to know what one is doing and all the issues involved, is spiritual suicide. Whether any soul ever reaches this I don't know. If he does, it can be only through a continuous and final determination to choose evil knowing it to be evil. But no one can be saved against his own free will—no, not even by the precious blood of Christ.

And what of the word "blood"? When we realize, on the one hand, that of ourselves we are quite incapable of making ourselves *whole*, of responding to God's demand for *holiness*—the two words have the same root—when we realize, on the other hand, what it cost Christ to come to our aid, is the word "blood" really out of place, however much we may have shuddered at crude language which uses it glibly? To give one's blood for a cause or a person represents uttermost self-giving. When the word "blood" offends, we might well paraphrase by "uttermost self-giving." In the same way we speak of giving our *life* for another; and, as Jesus said, "Greater love hath no man than

this, that a man lay down his life for his friends." [29] We speak of a man's *life blood*. The blood is the life.[30] Paul uses the phrase "saved by his life." [31] The background of the New Testament understanding of the meaning of the Cross was provided by the temple sacrifices where blood was offered to God on behalf of man. Christ did that very thing. He still does it in the sense that he is still pouring out his energies (= life) for us. For such activity while still in the flesh the symbol is obviously blood. The blood is the life. In his life, in his death, in his life after death, in his endless ministry for men now, he offers uttermost self-giving that he may change our nature and make us like himself. This is the great deliverance to which he committed himself. In the days of his flesh he evidenced that uttermost self-giving by going as far as man can go while still in the flesh, namely by pouring out his very blood. How natural, then, that "blood" should be the word which, more than any other, has come to symbolize a self-giving not only once on the Cross, but a self-giving which can cease only when the last soul who can still make response makes it and is thereby saved—saved, that is, from the separation from God of which I have written and from consequent despair; saved, to use the New Testament word, from hell; saved by his precious blood, or, if you prefer it, by the love of which the voluntarily shed blood is both the symbol and the pledge.

[29] John 15:13.
[30] Gen. 9:4.
[31] "If, while we were enemies, we were reconciled to God through the death of his Son, much more, being reconciled, we shall be saved by his life." (Rom. 5:10.)

Having criticized one stanza of Cowper's hymn, let me with the fullest gratitude quote another:

> Dear dying Lamb, thy precious blood
> Shall never lose its power,
> Till all the ransomed church of God
> Be saved, to sin no more.

All I have to do, sinful and, without Christ, hopeless, is surrender to that love and co-operate with one already at work, who is committed, unless I finally slam the door in his face, to the task of my salvation. By that love, of which poured-out blood was the visible symbol in the days of his flesh, he saves us in the sense that he will never, unless we so choose, leave us in that horror of great darkness and loneliness where God is unperceived and where the unrescued soul must perish.

So, after all, we are not far from the view of our grandfathers, who sang much about "the blood." We too, nineteen hundred years after the historic crucifixion on Calvary, are saved by the outpoured love of which blood is the symbol. We have made a circuitous journey in order to try to look at the Cross through the eyes of the plain man of today. But we all find our unity, both of need and of satisfaction, at its foot.

> To an open house in the evening
> Home shall men come,
> To an older place than Eden
> And a taller town than Rome.
> To the end of the way of the wandering star,
> To the things that cannot be and that are,

To the place where God was homeless
And all men are at home.[32]

I have no quarrel with the grand old Methodism in which I was brought up. I can sing, without any silly supposed superiority, nearly all the Methodist revival hymns; and in my heart I rejoice above everything else in the world—and I am using words carefully—that I have been led to trust not in myself, or any alleged merit of mine, but in him who loved me and gave himself up for me. In him alone is hope either for the individual or for the world. But all we do need is there, freely offered and to be taken —in faith.

I may go back on Christ. I know myself and my past record well enough to say that probably I shall. But as I write these words I know that he is my only hope of becoming what in my best moments I want to be. In all the confusion and uncertainty and bewilderment of today, certainty lies there.

Now I have found the ground wherein
Sure my soul's anchor may remain.

In all the choices of direction which lie before the human soul in its journey through this world, where he beckons there a steady light shines and a voice says, "I am the way." Glittering prizes dazzle the eyes of men and women from time to time, and we all are tempted at some point or another to try to grasp them. But heart's peace is the only one worth possessing. Thousands who now hold in their hands the prize they struggled so long to get their hands on

[32] From "The House of Christmas," *The Collected Poems of G. K. Chesterton.*

find that peace of mind, simple joys, and the capacity to be made happy by simple things like a sunset, a day in the country watching birds, or the love of a child, or a piece of unselfish service to another, have eluded them.

> Art thou poor, yet hast thou golden slumbers?
> O sweet content!
> Art thou rich, yet is thy mind perplex'd?
> O punishment! [33]

Oh, that Cross of Christ, how grim and stark it looks! We would fain look the other way. We want life not death; we want to enjoy ourselves, not to suffer. We want the fair things of life—health and hilarity and a place in the sun and power over others and comfort and security and that "serene that men call age." Why must this Cross of pain and self-sacrifice and utter self-giving dominate the whole landscape as soon as we look in the direction of religion? So, unheeding, uncaring, selfish, and self-absorbed we go on our way. "Beware what you set your heart on, for it shall surely be yours," said Emerson. "'Take what you want,' said God, 'take it and pay for it,'" so runs a Spanish proverb. Then when we've taken the wrong road, followed the wrong light, won the poisonous prize we coveted, and gathered the possessions we thought would make us glad, life crashes in on us in one of a thousand ways.

> Canst drink the waters of the crispèd spring?
> O sweet content!
> Swim'st thou in wealth, yet sink'st in thine own tears?
> O punishment!

[33] Thomas Dekker, "Sweet Content."

Then he that patiently want's burden bears,
No burden bears, but is a king, a king!
O sweet content! O sweet, O sweet content![84]

Yes, life will work only one way, and that is Christ's way. There's a precipice at the end of every other road. Broken, bruised, disillusioned, despairing, we know then that of ourselves and by ourselves and in ourselves there is no hope of finding anything but the hell of a great despair. *"Outside God there is only death."* I wish I could persuade the reader of that before he finds it out for himself.

If I could, he would kneel with me now at the foot of that Cross that expressed Christ's uttermost once and for all, and is the pledge of the same quality of love offered for us all forever. And we should put down all our good deeds that we hoped might count as merit, and all our bad deeds that we feared would make him hate us—our indifference to the needs of others, our lack of understanding and sympathy, all the grosser things like cowardice and lust and hypocrisy, and all the cunning forms which pride and selfishness take, concealing our motives from our scrutiny—and we should ask the great God to forgive us for Jesus Christ's sake; and, prostrate at the feet of the Master who died and rose again, and who still offers us his succor, we should ask him to dwell in us, to guide us, to empower us, to make us anew, to do indeed a Saviour's work. And "in Christ" there is not one of us who could not be made more than he dreams, and find in Christ such joy and peace as would leave him with nothing else to ask. All this Jesus Christ can and will do, for he is indeed the Saviour of the world.

[84] *Ibid.*

THE MEANING OF THE CROSS

Here might I stay and sing,
 No story so divine;
Never was love, dear King!
 Never was grief like thine.
 This is my Friend,
 In whose sweet praise
 I all my days
 Could gladly spend.

CHAPTER VIII

Epilogue

I HAVE tried to write simply that the plain man might understand. If I have failed, let him find comfort in the fact that the message of the Cross does not depend for its efficacy on being understood. Thousands have been saved who have never understood. In fact, no one fully understands.

> We may not know, we cannot tell,
> What pains he had to bear.

Thousands have looked and believed and found peace. They have "known" without understanding and been "saved" without being able to explain. The quality of their lives proves the reality of their Saviour's work within them. Plain folk? Yes. But they looked at the Cross, and its message of saving love came home to them through simple faith. If you asked them theological questions, you could tie them up in knots. But nothing will ever take their certainty from them. "He died for me," they whisper as they look and worship. And they have no questions left to ask.

One of the most astonishing things in the world is that even uncivilized peoples who have never heard the story of the Cross before seem to catch its message and meaning,

without any theological understanding at all. A native in Bechuanaland, on hearing the story of the Cross, was deeply moved and said, "Jesus, away from there. That is my place." [1] And in 1840 Bishop Selwyn, who was a missionary among the cannibal Maoris of New Zealand, wrote:

I am in the midst of a sinful people, who have been accustomed to sin uncontrolled from their youth. If I speak to a native on murder, infanticide, cannibalism, and adultery, they laugh in my face, and tell me I may think these acts are bad, but they are very good for a native, and they cannot conceive any harm in them. But on the contrary when I tell them that these and other sins brought the Son of God, the great Creator of the universe, from his eternal glory to this world, to be incarnate and to be made a curse and to die—then they open their eyes and ears and mouths, and wish to hear more, and presently they acknowledge themselves sinners, and say they will leave off their sins. [2]

I leave the facts with you. You must make your own response. But I have yet to learn of any story movingly told of any martyr in the long and glorious history of the saints when that reaction has been registered. The story underlines a sentence I wrote earlier, that the substitution theory includes a truth which we cannot let go.

Swing now to the opposite end of the social scale. The scene is the Queen's Hall, London. A cultured audience has gathered to listen to a concert. Here you have not the uncivilized savage possessing little of culture or education. You have the West End of London rolling up in expensive motor cars and stepping from them in evening

[1] Quoted in Charles H. Robinson, *Studies in the Passion of Jesus Christ.*
[2] *Life of Bishop Selwyn*, p. 72.

dress. One of the items on the program is a song by a young girl whose name is unknown. She is making her first appearance before the critical musical public of London. She sings, with perfect voice and that artless grace which is the height of art, a song which she has practiced many hours with her distinguished tutor. At the end of the song the applause is deafening and continued, and both tutor and audience demand that she shall sing again. Once again she sings the same song.

But it is a long time since the audience has heard anything so fresh and understanding and altogether captivating. It is imperative that she should sing yet again. Hurriedly she and her tutor confer together. She has arranged to sing only this one song. The tutor was not ready to risk more. She was to have this one chance only. "What else have you got?" he asks. From her music case she takes out a song and says very simply, "I should like to sing this to them." She goes on to the platform. The noise and tumult and cheering subside. In perfect stillness she begins:

> There is a green hill far away,
> Without a city wall,
> Where the dear Lord was crucified,
> Who died to save us all.

She sings it to Gounod's glorious setting. The effect is electrical. It is a long time since many of those who listen have heard any religious message, and a very long time indeed since they have heard the message of the Cross. The beautiful voice goes on:

> We may not know, we cannot tell,
> What pains he had to bear;

But we believe it was for us
He hung and suffered there.

The silence becomes almost tangible. The tension is almost more than people can bear, and still the voice goes on:

He died that we might be forgiven,
He died to make us good,
That we might go at last to heaven,
Saved by his precious blood.

No chocolate boxes are passed during that song. No whispered comments of the singer's ability are exchanged. That night, in the Queen's Hall, the singer is forgotten by many, in a song which carries them away on its wings to a lonely hill outside a city, where a Man whose great loyalty and love nothing could break—a Man who was all that God could pour of himself into a human personality—hung in anguish on a cross of shame.

There was no other good enough
To pay the price of sin;
He only could unlock the gate
Of heaven, and let us in.

There are not many dry eyes. Women weep openly, unable to restrain their tears. Men grip the seat in front of them, their knuckles white with the intensity of their grip, their faces strained by the depth of their emotion. The singer seems almost unconscious of the audience. She is singing a song so precious to her own heart that she is not singing to please the audience. She has forgotten it is there. She is bearing out through Gounod's music the adoration

of her own heart for the crucified Lord. So to those final and wonderful notes the young voice travels on:

> O dearly, dearly has he loved,
> And we must love him, too,
> And trust in his redeeming blood,
> And try his works to do.

The soloist forgets to bow. Certainly the audience notices no omission. There is no applause—only a great silence.

So in Africa, so in London, so with the outcaste, so with the educated and civilized, so with men in olden days, so with modern men and women who are willing to be quiet and to consider, his words are true, and they are true only of him: "I, if I be lifted up from the earth, will draw all men unto myself." [3] And when, bound to his Cross, he is lifted up before men's eyes, by some strange power which defies analysis, dying he brings them life; bound he brings them liberty; suffering he redeems them from the greatest anguish the soul can know, the agony of hopeless despair; and everlastingly loving he challenges them, and claims them, and will never let them go until he makes them his forever.

[3] John 12:32.

APPENDIX I

The Words of Jesus About His Own Passion[1]

The Markan Sayings

1. THE STATEMENT ABOUT THE REMOVAL OF THE BRIDEGROOM

Can the sons of the bridechamber fast, while the bridegroom is with them? As long as they have the bridegroom with them, they cannot fast. But the days will come, when the bridegroom shall be taken away from them, and then will they fast in that day. (Mark 2:19-20; cf. Matt. 9:15; Luke 5:34-35.)

2. THE SAYINGS ON THE SUFFERING AND REJECTION OF THE SON OF MAN

a) And he began to teach them, that the Son of man must suffer many things, and be rejected by the elders, and the chief priests, and the scribes, and be killed, and after three days rise again. (Mark 8:31; cf. Matt. 16:21; Luke 9:22.)

b) For he taught his disciples, and said unto them, *The Son of man is delivered up into the hands of men, and they shall kill him; and when he is killed, after three days he shall rise again.* (Mark 9:31; cf. Matt. 17:22-23; Luke 9:44.)

c) *Behold, we go up to Jerusalem; and the Son of man shall be delivered unto the chief priests and the scribes; and they shall condemn him to death, and shall deliver him unto the Gentiles: and they shall mock him, and shall spit upon him,*

[1] Adapted from Vincent Taylor, *Jesus and His Sacrifice*, by permission of the author and the publisher, The Macmillan Co.

and shall scourge him, and shall kill him; and after three days he shall rise again. (Mark 10:33-34; cf. Matt. 20:18-19; Luke 18:31-33.)

3. THE SAYING AT THE DESCENT FROM THE MOUNT OF TRANS-FIGURATION

And how is it written of the Son of man, that he should suffer many things and be set at nought? (Mark 9:12b; Matt. 17:12b.)

4. THE SAYING ON THE CUP AND THE BAPTISM

Are ye able to drink the cup that I drink? or to be baptized with the baptism that I am baptized with? (Mark 10:38; cf. Matt. 20:22.)

5. THE "RANSOM" PASSAGE

For verily the Son of man came not to be ministered unto, but to minister, and to give his life a ransom for many. (Mark 10:45; cf. Matt. 20:28.)

6. THE PARABLE OF THE VINEYARD

He had yet one, a beloved son: he sent him last unto them, saying, They will reverence my son. But those husbandmen said among themselves, This is the heir; come, let us kill him, and the inheritance shall be ours. And they took him, and killed him, and cast him forth out of the vineyard. (Mark 12:6-8; cf. Matt. 21:37-39; Luke 20:13-15a.)

7. THE SAYING IN THE STORY OF THE ANOINTING

She hath anointed my body aforehand for the burying. (Mark 14:8; cf. Matt. 26:12.)

8. THE PROPHECY OF THE BETRAYAL

And when it was evening, he cometh with the twelve. And as they sat and were eating, Jesus said, *Verily I say unto you,*

One of you shall betray me, even he that eateth with me. They began to be sorrowful, and to say unto him one by one, Is it I? And he said unto them, *It is one of the twelve, he that dippeth with me in the dish. For the Son of man goeth, even as it is written of him: but woe unto that man through whom the Son of man is betrayed! good were it for that man if he had not been born.* (Mark 14:17-21.)

9. THE SAYINGS AT THE LAST SUPPER

a) *Take ye: this is my body.* (Mark 14:22.)

b) *This is my blood of the covenant, which is shed for many.* (Mark 14:24.)

c) *Verily I say unto you, I will no more drink of the fruit of the vine, until that day when I drink it new in the kingdom of God.* (Mark 14:25; cf. Matt. 26:26-29; Luke 22:14-20; I Cor. 11:23-25.)

10. TWO OLD TESTAMENT QUOTATIONS: THE STONE; THE SHEPHERD

a) *The stone which the builders rejected,*
The same was made the head of the corner:
This was from the Lord,
And it is marvelous in our eyes.

(Mark 12:10-11.)

b) And Jesus saith unto them, *All ye shall be offended: for it is written,*

I will smite the shepherd,
And the sheep shall be scattered abroad.

(Mark 14:27.)

11. THE GETHSEMANE SAYINGS

a) *My soul is exceeding sorrowful even unto death; abide ye here, and watch.* (Mark 14:34; cf. Matt. 26:38; Luke 22:40.)

179

b) And he said, *Abba, Father, all things are possible unto thee; remove this cup from me: howbeit not what I will, but what thou wilt.* (Mark 14:36; cf. Matt. 26:39, 42; Luke 22:42.)

c) And he cometh, and findeth them sleeping, and saith unto Peter, *Simon, sleepest thou? couldest thou not watch one hour? Watch and pray, that ye enter not into temptation: the spirit indeed is willing, but the flesh is weak.* (Mark 14:37-38; cf. Matt. 26:40-41; Luke 22:45-46.)

d) And he cometh the third time, and saith unto them, *Sleep on now, and take your rest: it is enough; the hour is come; behold, the Son of man is betrayed into the hands of sinners. Arise, let us be going: behold, he that betrayeth me is at hand.* (Mark 14:41-42; cf. Matt. 26:45-46.)

e) And Jesus answered and said unto them, *Are ye come out, as against a robber, with swords and staves to seize me? I was daily with you in the temple teaching, and ye took me not: but [this is done] that the Scriptures might be fulfilled.* (Mark 14:48-49; cf. Matt. 26:55-56; Luke 22:52-53.)

12. THE CRY FROM THE CROSS

And at the ninth hour Jesus cried with a loud voice, *Eloi, Eloi, lama sabachthani?* which is, being interpreted, *My God, my God, why hast thou forsaken me?* (Mark 15:34; Matt. 27:46.)

The Sayings in the L Tradition

1. THE SAYING ABOUT THE COMING BAPTISM

> *I came to cast fire upon the earth;*
> *And what will I, if it is already kindled?*
> *But I have a baptism to be baptized with;*
> *And how am I straitened till it be accomplished?*
>
> (Luke 12:49-50.)

2. The Reply to Herod Antipas

And he said unto them, *Go and say to that fox, Behold I cast out devils and perform cures today and tomorrow, and the third day I am perfected. Howbeit I must go on my way today and tomorrow and the day following: for it cannot be that a prophet perish out of Jerusalem.* (Luke 13:32-33.)

3. The Suffering and Rejection of the Son of Man

But first must he suffer many things and be rejected of this generation. (Luke 17:25.)

4. The Sayings Connected with the Last Supper

a) And he said unto them, *With desire I have desired to eat this passover with you before I suffer: for I say unto you, I will not eat it, until it be fulfilled in the kingdom of God.* (Luke 22:15-16.)

b) And he received a cup, and when he had given thanks, he said, *Take this, and divide it among yourselves: for I say unto you, I will not drink from henceforth of the fruit of the vine, until the kingdom of God shall come.* (Luke 22:17-18; cf. Mark 14:25.)

5. Sayings in the Conversations After the Supper

a) *I am in the midst of you as he that serveth.* (Luke 22:27; cf. Mark 10:41-45.)

b) *But ye are they which have continued with me in my temptations; and I appoint unto you a kingdom, even as my Father appointed unto me, that ye may eat and drink at my table in my kingdom; and ye shall sit on thrones judging the twelve tribes of Israel.* (Luke 22:28-30; cf. Matt. 19:28.)

c) *For I say unto you, that this which is written must be fulfilled in me, And he was reckoned with transgressors: for that which concerneth me hath an end.* (Luke 22:37.)

6. The Saying at the Arrest About the Power of Darkness

But this is your hour, and the power of darkness. (Luke 22:53b.)

7. The Crucifixion Sayings

a) And Jesus said, *Father, forgive them; for they know not what they do.* (Luke 23:34.)

b) And he said, Jesus, remember me when thou comest in thy kingdom. And he said unto him, *Verily I say unto thee, Today shalt thou be with me in Paradise.* (Luke 23:42-43.)

c) And when Jesus had cried with a loud voice, he said, *Father, into thy hands I commend my spirit*: and having said this, he gave up the ghost. (Luke 23:46.)

The Sayings in the Pauline Narrative of the Last Supper

a) *This is my body, which is for you: this do in remembrance of me.* (I Cor. 11:24.)

b) *This cup is the new covenant in my blood: this do, as oft as ye drink it, in remembrance of me.* (I Cor. 11:25.)

The Johannine Sayings

Passion Sayings Attributed to Jesus Himself in the Fourth Gospel

a) Destroy this temple, and in three days I will raise it up. (John 2:19.)

b) I am the living bread which came down out of heaven: if any man eat of this bread, he shall live forever: yea and the bread which I will give is my flesh, for the life of the world. (John 6:51.)

c) Verily, verily I say unto you, Except ye eat the flesh of the Son of man and drink his blood, ye have not life in yourselves. He that eateth my flesh and drinketh my blood hath

eternal life; and I will raise him up at the last day. For my flesh is meat indeed, and my blood is drink indeed. He that eateth my flesh and drinketh my blood abideth in me, and I in him. As the living Father sent me, and I live because of the Father; so he that eateth me, he also shall live because of me. (John 6:53-57.)

d) My time is not yet come. (John 7:6.)

e) My time is not yet fulfilled. (John 7:8.)

f) When ye have lifted up the Son of man, then shall ye know that I am he, and that I do nothing of myself, but as the Father taught me, I speak these things. (John 8:28.)

g) I am the good shepherd: the good shepherd layeth down his life for the sheep. (John 10:11.)

h) And I lay down my life for the sheep. And other sheep I have, which are not of this fold: them also I must bring, and they shall hear my voice; and they shall become one flock, one shepherd. (John 10:15-16.)

i) Therefore doth the Father love me, because I lay down my life, that I may take it again. No one taketh it away from me, but I lay it down of myself. I have power to lay it down, and I have power to take it again. This commandment received I from my Father. (John 10:17-18.)

j) Suffer her to keep it against the day of my burying. (John 12:7.)

k) The hour is come, that the Son of man should be glorified. Verily, verily, I say unto you, Except a grain of wheat fall into the earth and die, it abideth by itself alone; but if it die, it beareth much fruit. He that loveth his life loseth it; and he that hateth his life in this world shall keep it unto life eternal. (John 12:23-25.)

l) Now is my soul troubled; and what shall I say? Father, save me from this hour? But for this cause came I unto this hour. Father, glorify thy name. (John 12:27-28.)

m) Now is the judgment of this world: now shall the prince of this world be cast out. And I, if I be lifted up from the earth, will draw all men unto myself. (John 12:31-32.)

n) Verily, verily, I say unto you, that one of you shall betray me. (John 13:21.)

o) I go to prepare a place for you. (John 14:2.)

p) Greater love hath no man than this, that a man lay down his life for his friends. (John 15:13.)

q) Nevertheless I tell you the truth; It is expedient for you that I go away: for if I go not away, the Comforter will not come unto you; but if I go, I will send him unto you. (John 16:7.)

r) Father, the hour is come; glorify thy Son, that the Son may glorify thee: even as thou gavest him authority over all flesh, that whatsoever thou hast given him, to them he should give eternal life. (John 17:1-2.)

s) And for their sakes I sanctify myself, that they themselves also may be sanctified in truth. (John 17:19.)

t) Woman, behold, thy son! . . . Behold, thy mother. (John 19:26, 27.)

u) I thirst. (John 19:28.)

v) It is finished. (John 19:30.)

APPENDIX II

Questionary

Chapter I—Dissatisfaction

1. Put into words which a person of fifteen could understand what Christ's death on the Cross means to you.
2. Can harm come by asking too many questions? Mr. Jones says they upset and muddle him. He says it is enough if one has faith and asks no questions. Do you agree?
3. Take some of the questions on pp. 33-35 and answer them without reading further.

Chapter II—How Jesus Came to His Cross

1. Do you think that Jesus believed from the beginning of his ministry that it was God's will that he should die? Are there difficulties in this view? If he *had* to die, were those who plotted his death pawns in a game and free from guilt?
2. Does your conception of Jesus leave room for the possibility of his changing his mind? Is it possible that he had grave hours of doubt as to which way God wanted him to go?
3. Let a group member read the parable of the wicked husbandmen in Mark 12:1-12. Does God destroy those who reject his Son? (Vs. 9.) Does this fit in with your picture of God as revealed in Jesus?
4. If we proclaim that God can use evil, as suggested on p. 54, do we not lessen in men's minds the need for goodness?

Chapter III—What Jesus Said About His Cross

1. What exactly did Jesus mean by the word "must" in the passages on p. 58? Did he mean certain things were destined or ordained, or merely that he ought to do them from a sense of duty? Compare our use of the word and say if you would like to be visited when ill by a minister because the latter felt he *must* visit the sick!

2. How can Christ's death be at the same time a purpose of God and the sin of wicked men?

3. What is your reaction to Dr. Moffatt's translation of I Cor. 11:24—"This *means* my body"?

Chapter IV—The Task to Which Jesus Committed Himself

1. Would the denial of the existence of Christ before his life on earth impoverish faith? If so, in what way and to what extent?

2. How would you comfort an Indian convert who grieved because his father had died without ever hearing about Christ?

3. Is it an important part of Christian faith to believe that Christ's kingdom will come on earth?

4. In what sense will men ever be like Christ? In what sense will he always be different from them?

Chapter V—How Men Have Interpreted the Cross

1. When you sing, "I lay my sins on Jesus," what do you really mean?

2. Can there be in any real sense a transfer of guilt?

3. Do we not all pay the penalty of our own sins; so what need is there for anyone else to bear them for us?

4. It is sometimes said that God loves the sinner but hates the

sin. Can the two really be separated? Is it our sins or our sinfulness that constitute the hub of our difficulty?

Chapter VI—The Cost of Our Deliverance

1. Do you believe that, at the Ascension, Christ returned to share with God the glory he had with him before the world was created, or do you believe that he is still human?
2. Does the idea of Christ as Bridegroom mean: (a) that all mankind must belong to the church—in the widest sense—before Christ's work is done and his kingdom "comes" on earth? (b) that finally no human creature can be "lost"?
3. Is Christ at his redeeming work in the hearts of those who ignore, reject, or are ignorant of him?

Chapter VII—The Manner of Our Deliverance

1. Do you think you will feel a burden of guilt forever for what you have done, or might have done and haven't? Or will you "forget"? If a sense of guilt is dispelled, *how* is it dispelled?
2. Discuss the words so often used at the end of a prayer, "Through Jesus Christ our Lord." Wouldn't God hear us except through Jesus? If not, what happened to the prayers of Old Testament saints?
3. What is the real penalty of sin? How does Christ save us from it?
4. Explain "justification by faith" to a boy of fifteen.
5. If hell, at least in part, is the anguish of self-discovery, would it not be better to find oneself out now? How can we set about it?
6. Define the word "happiness" and say how it may be found. Is "joy" something different? If so, what is the difference?
7. What is the first task of the church—to inaugurate reforms or to get men "saved"?
8. Are you saved? What are you going to do about it?